CONTENTS

ACKNOWLEDGEMENTS

This book has come about through the skills, talent and scholarship of many people. Apart from those listed on the title page, I would like to thank Francesca Galloway, Richard Foenander, Eric Bradley and especially Gillian Bate whose editorial advice has been invaluable.

INTRODUCTION

Historians of Byzantine art in the last fifty years have pointed more and more clearly in the direction of Hellenistic culture for the origins of Christian art. At the same time students of philosophical and religious ideas have begun to see, in the gnostic and mystery cults of Hellenism at the dawn of our era, elements of a universal wisdom common to all religions.

These trends invite us to look in a new way at the thought of men and women who lived around the eastern Mediterranean between a thousand and two thousand years ago. At that time new ideas were founding the culture of which we still consider ourselves to be the inheritors. However, in their encounter with the vicissitudes and follies of human nature over a long historical period, these ideas have been compromised and have changed direction many times; and it is now as though they have come full circle so that civilisation will soon be standing once again on the threshold of a new era. Intellectually the West is ridding itself of a great deal of superstition and other forms of nonsense and, paradoxically, provided that we do not become merely cynical, this may lead us to a clearer view of the meanings at the origins of our religion and culture.

A first glimpse into early Christian times is provided by the liturgical objects, works of art, ornaments and mementoes illustrated on the following pages. The period they come from is the lens through which Hellenistic life and religion passed in the gradual process of becoming Christianity.

Part of the aim in assembling this material is to bring together objects and works of art from a world where, in the early stages, Christians and pagans lived side by side. The period from which these objects are drawn begins with the fourth century, when Christianity first became the religion of the Roman state. Other works of art considered here date from as late as the fourteenth century, the moment just before the demise of the Eastern Christian world and the emergence of Western European culture from the Middle Ages. The culture of the late Roman Empire was composed of a mixture of Arabian, Persian, African, Jewish, Greek and Egyptian influences. Into this Hellenistic milieu appeared Christianity. But we do not know much about this event, it is obscured from us by what Gibbon called a 'mysterious veil'. We can only say that it then had not the form and the organisation by which we identify it today. At the beginning Christianity was an obscure underground cult, ignored by the establishment and oppressed by the authorities. Like the older Mystery Religions of Greece and Egypt it was a purely spiritual movement concerned with the transformation of the human side of life by the divine. The teachings were communicated orally and, only where necessity demanded, by writings. Art was employed hardly at all. This is why, with the exception of a few frescoes at Dura Europos, and in the catacombs and some sculptured stone sarcophagi, Christianity left little impression on the arts in the earliest period.

The early Christians were not interested in art 'for its own sake'. Early Christian imagery mainly consisted of signs such as the cross (nos. 19, 48–58, 59–64, 65–74), fish

(nos. 21, 28, 42) or birds (nos. 18, 22, 29, 32, 33, 41, 43). The function of these images was to serve as a kind of shorthand for various ideas associated with Christ's Life, Death and Resurrection. On sixth- to ninth-century crosses we find sometimes rather laconic graffiti depicting Christ (nos. 49, 52), the Mother of God (nos. 48–57) or various saints (nos. 54, 57). The style of these objects was conservative, and their art had a kind of beauty, though not of course according to the classical canons. The fifth- or sixth-century stone frieze with birds (no. 18), with its quiet rhythm and its unaffected integrity, expresses an inner confidence very different from the smart worldliness of the pagans.

At the same time there were other Christian groups, drawing on different traditions, and perhaps exploring different spiritual aims, who developed an aspect of the portrait image and brought to it great psychological force.

Three distinct traditions can be observed in the art of portraiture that had been evolving over many centuries in the pre-Christian era. Firstly, portraits had been widely employed among the Romans: images of the emperor and of his representatives, universally displayed throughout the empire, had long been used as symbols of imperial authority. Secondly, from ancient time, there was a tradition, also using the image of the human face, of personifying divine powers, forces of nature and of moral qualities and virtues (nos. 2 and 3). Thirdly, in some religious circles, especially in Egypt, elaborate ritual portraits continued to be made. These were associated with death and the journey of the soul in the passage from earthly life to eternity (no. 1).

In the case of funeral portraits, the aim was for something beyond aesthetic appeal. As we see, in the case of the funerary shroud (no. 1), their function was to convey the necessary power and knowledge for immortality. In the case of the personifications of spring and summer (nos. 2 and 3), the intention was to convey an understanding of the relationship between the forces of Nature on earth and the divine powers that order them. These are magical arts whose function is religious and whose meaning is deeply spiritual.

The portrait icons of Christianity first appear in this context where imperial portraits, personifications and ritual funerary images were familiar. Unfortunately no icon has survived from as early as the fourth century, but we know they existed from a text which describes members of a certain religious sect – the Carpocratians – who had images of Plato, Christ, Apollo and other divine persons.

It is interesting that cult images such as the funerary shroud (no. 1) and the Coptic textiles (nos. 2, 3, and 4) were made as late as the end of the fourth century, that is, within the Christian period. Remembering that Christianity became the official religion of the Roman Empire in AD 313, we see that the transition from paganism to Christianity, in the arts at least, was gradual and sometimes imperceptible. For example, there are images, such as the shepherd figure in the catacombs described by Grabar as 'Orpheus-Christ', that cannot be distinguished clearly as either pagan or Christian since Orpheus was venerated by both.

What then is significantly Christian in early Christian art if the images do not clearly distinguish Christianity from paganism?

The establishing of the doctrinal and theological sides of Christianity began with the Council of Nicaea in AD 325 and was not finalised until several centuries, and six

Fig.1 Limestone Head, 2nd century. Private Collection, Montreal.

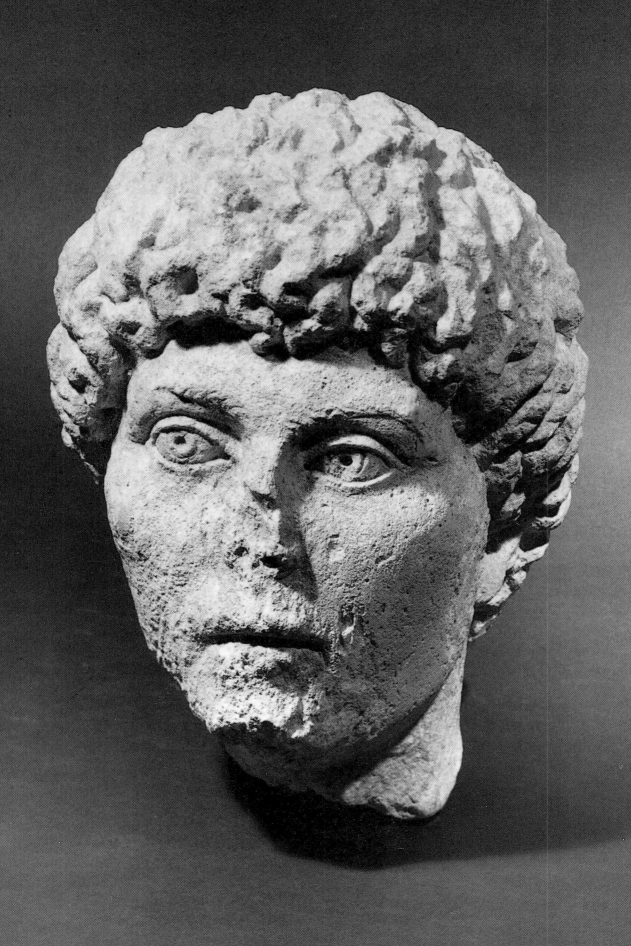

councils later. On the intellectual level it took a very long time to define precisely what was and what was not Christian. In the process many groups, adhering, as they believed, to more mystical or gnostic understandings of the earlier times found themselves beyond the pale of Orthodoxy and branded as heretics. But since art itself is not a language of words and does not speak primarily to the mind, it could be, and perhaps should be, non-dogmatic. At any rate we see that, for at least two centuries before Christianity's official recognition, art was already communicating religious and mystical qualities that differed from the worldly sophistication of the Romans or the decadent repetition of the Egyptians. Already in the second century, so-called pagan art seems at times to herald a new spirit, a new spirituality, which we recognise above all in the look of mystical love expressed in the eyes of portrait images.

A radical change was taking place: in the period of the Antonines, art that was officially pagan already signalled the inner revolution that was to take place in the minds of men and women two centuries later (fig. 1). The new spirit, therefore, was first communicated to the heart and to the spirit and only later to the mind. So it is not surprising that its qualities are of unaffected innocence, of disarming sincerity, of stillness, purity and silence.

The spirit of this deep inner sincerity, expressed through an art that was unsophisticated and close to the knowledge of the Mysteries, is to be found in the flowering of Christian art throughout the Byzantine world in its golden age. It finds supreme expression in the Paten of Paulus (no. 5) and in the haunting face of an apostle from a tenth-century fresco (no. 8). It did not even entirely disappear with the fall of Constantinople in 1453, for it was to continue for a hundred years or more in the Russian icons of the Novgorod and Moscow schools.

A second type of imagery emerges from late Hellenistic art which eventually becomes the 'Festival Scenes' of iconography. There are several examples in the collection assembled here that represent the beginnings of this kind of iconography. They are of great historical significance because they carry us back beyond the eighth and ninth centuries, the period of iconoclasm. Thus the scene of the Annunciation on the sixth- or seventh-century gold plaque (no. 6), which is so familiar to us from icons of a thousand years later, proves its origin in antiquity. Other pre-iconoclastic scenes, such as the Ascension of Christ (no. 34), and Daniel in the Lions' Den (nos. 24, 38), make their appearance – more or less for the first time in Christian art – on modest pieces of pottery and terracotta found in North Africa.

If, as many people instinctively sense, the cycle of history is bringing us once again to a new beginning, then we may be developing a new interest in the evidences remaining from what many once regarded as a dusty and forgotten corner of history and which is in fact a beacon of faith, hope and love. Several exhibitions have been held since 'Early Christian and Byzantine Art' at the Walters Art Gallery, Baltimore, in 1947; the most notable being 'The Age of Spirituality' at the Metropolitan Museum, New York, in 1977. The catalogue for the latter will surely remain the standard reference work on the subject for many years. More recently we have seen 'Spätantike zwischen Heidentum und Christentum' in Munich in 1989 and, also in 1989, 'Light in the Age of Darkness' at the Ariadne Gallery in New York. It is hoped that the present offering will be received in the light of this awakening.

RIGHT
Detail of **Cat.1**
Funerary Shroud,
Egypt, c.AD 350, (
page 10 and 25)

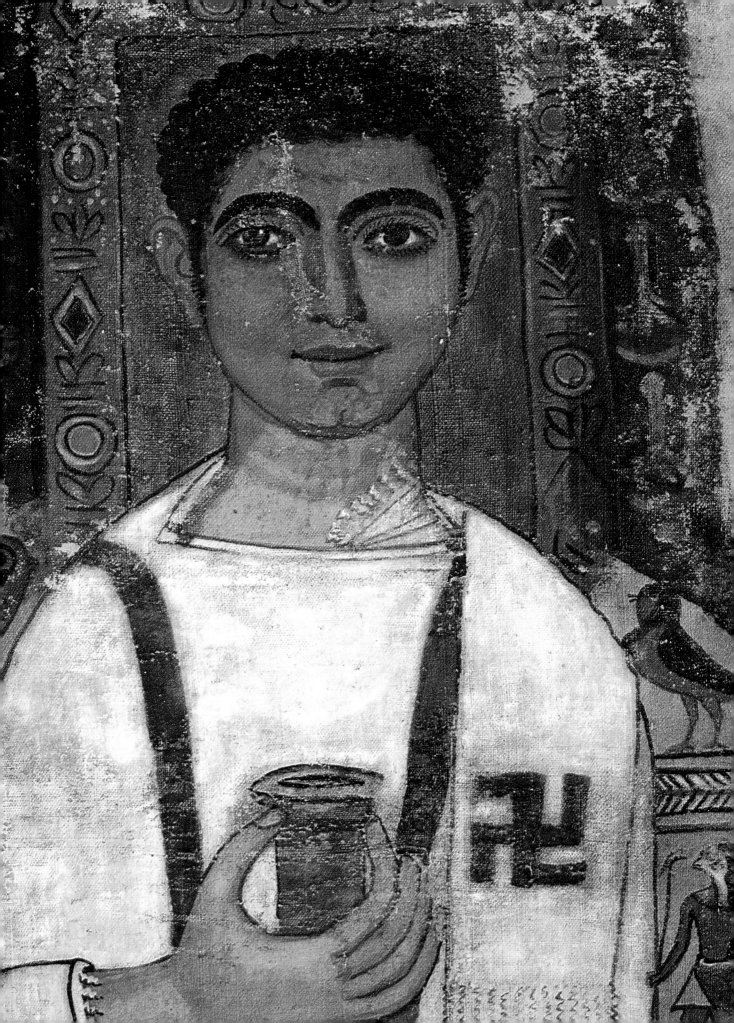

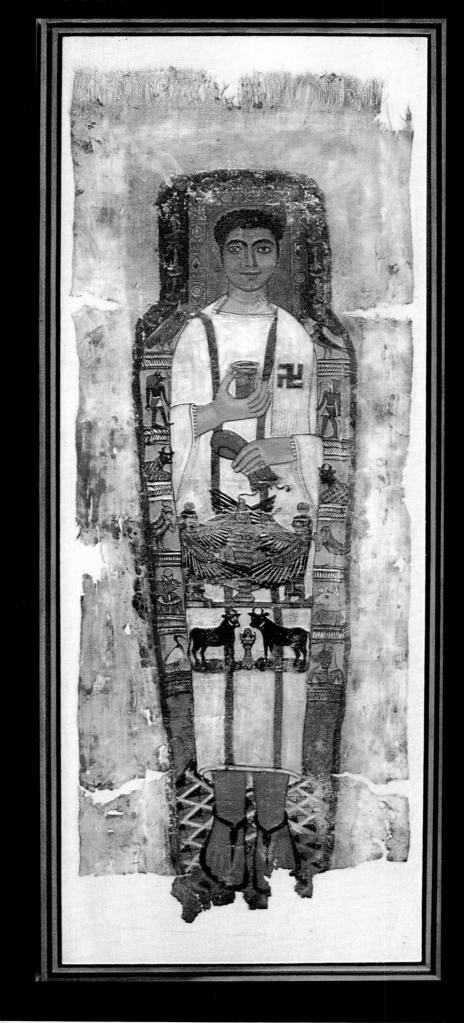

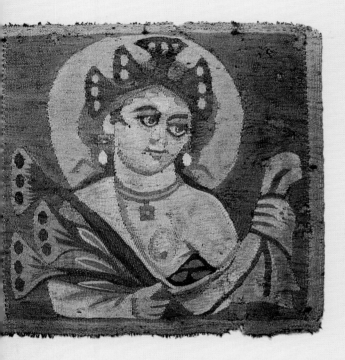 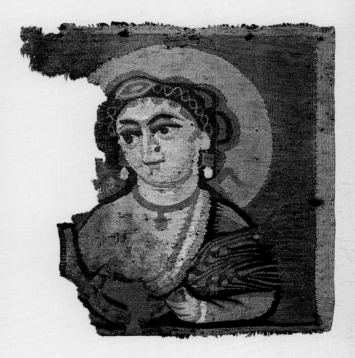

LEFT
Detail of **Cat.1** A Funerary Shroud, Egypt, *c*. AD 350, 194 × 73cm (See page 25)

ABOVE
Cat.2 & 3 Two textile panels, 'Spring' and 'Summer', Egypt, late 4th or early 5th century,
wool, 24.8 × 26cm and 24.6 × 25cm (See page 30)

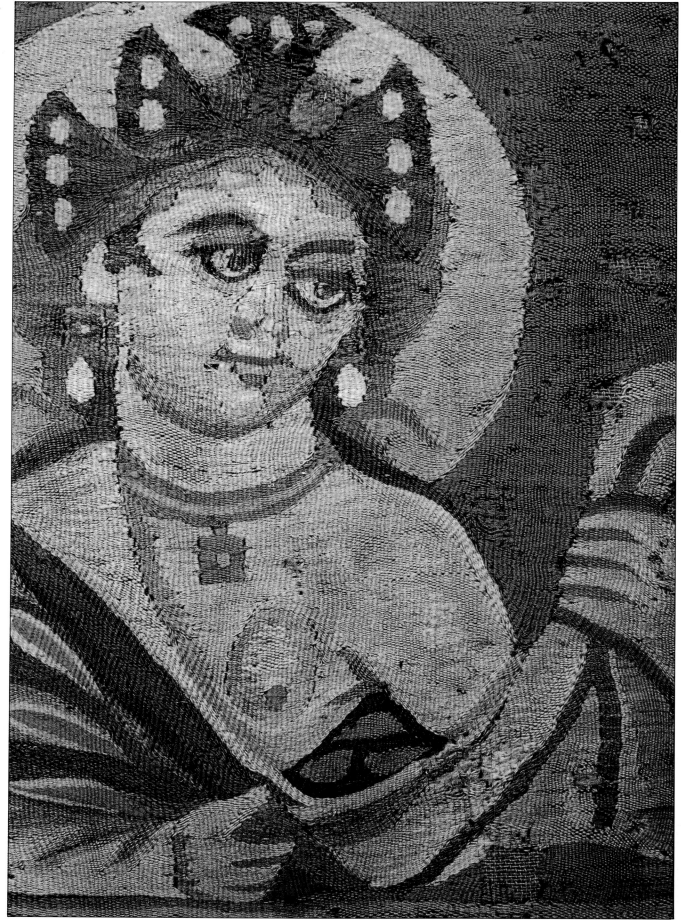

Detail of **Cat.2** A textile panel, 'Spring'

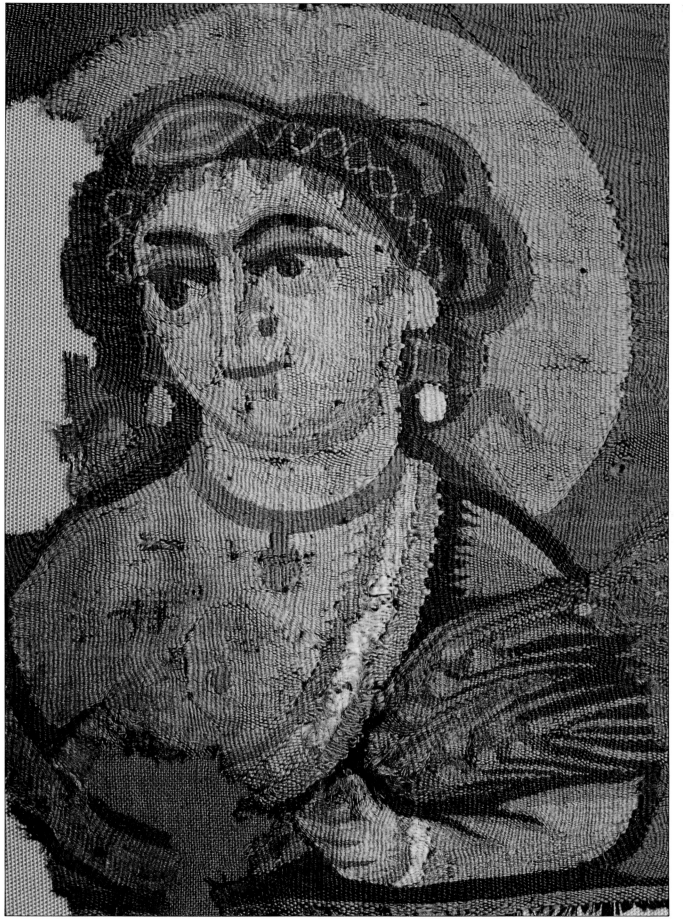

Detail of **Cat.3** A textile panel, 'Summer'

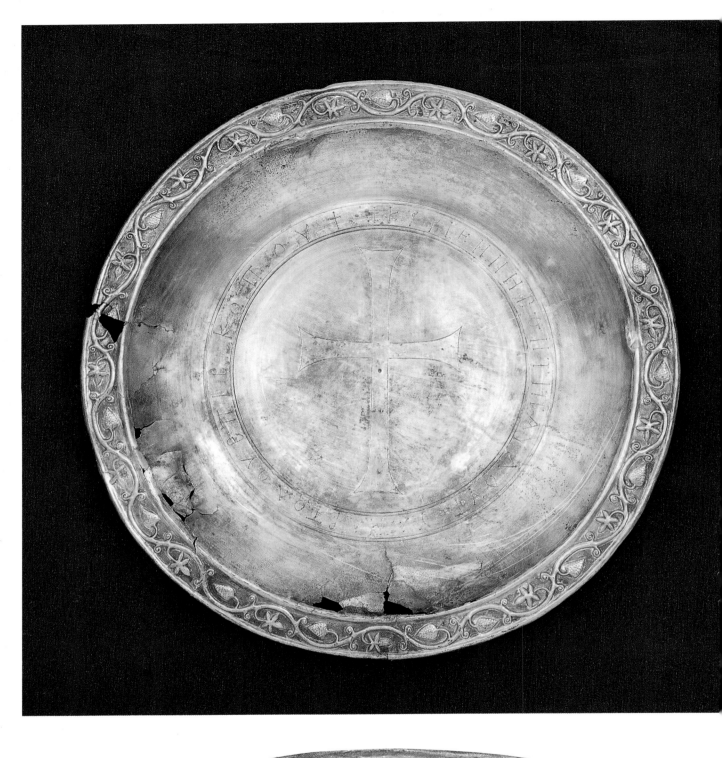

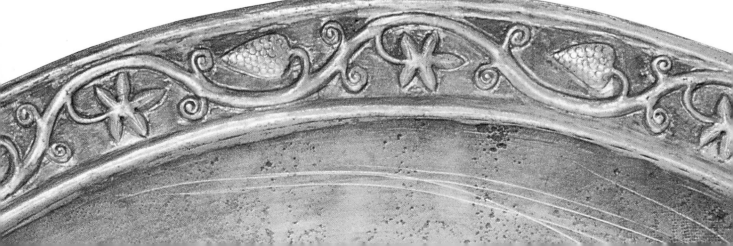

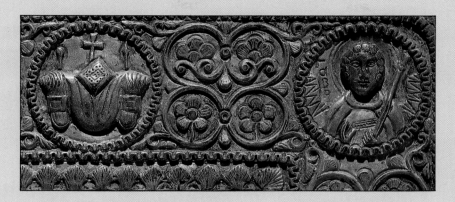

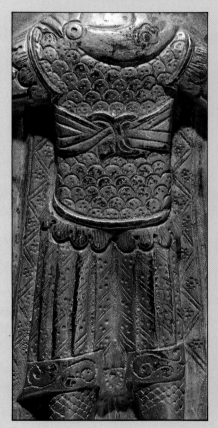

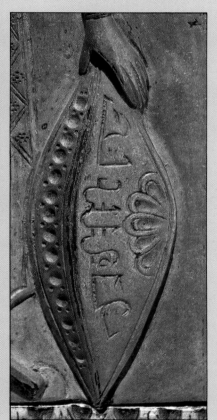

LEFT
Cat.5 Bishop Paul's Paten, Byzantine, 6th or 7th century, silver gilt,
diameter: 46cm (See page 34)
(Below) detail of border of Cat.5

ABOVE
Details of **Cat.7** St George, probably Constantinople, late 11th or early
12th century, silver gilt repoussé, 17.1 × 13.7 cm (See front cover and page 40)

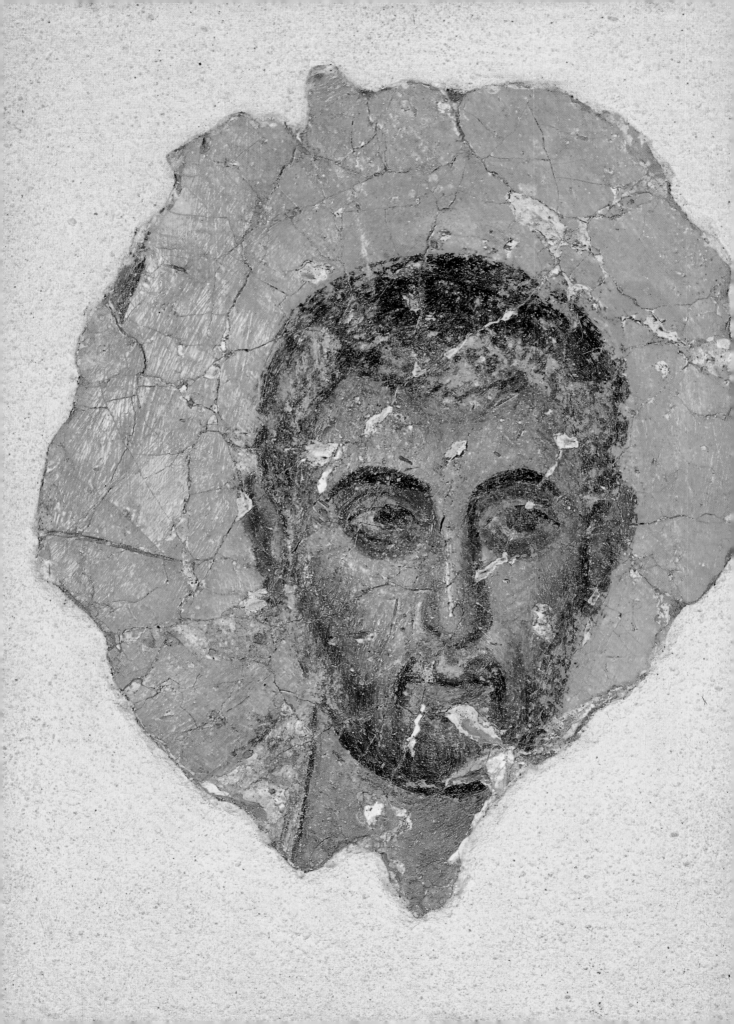

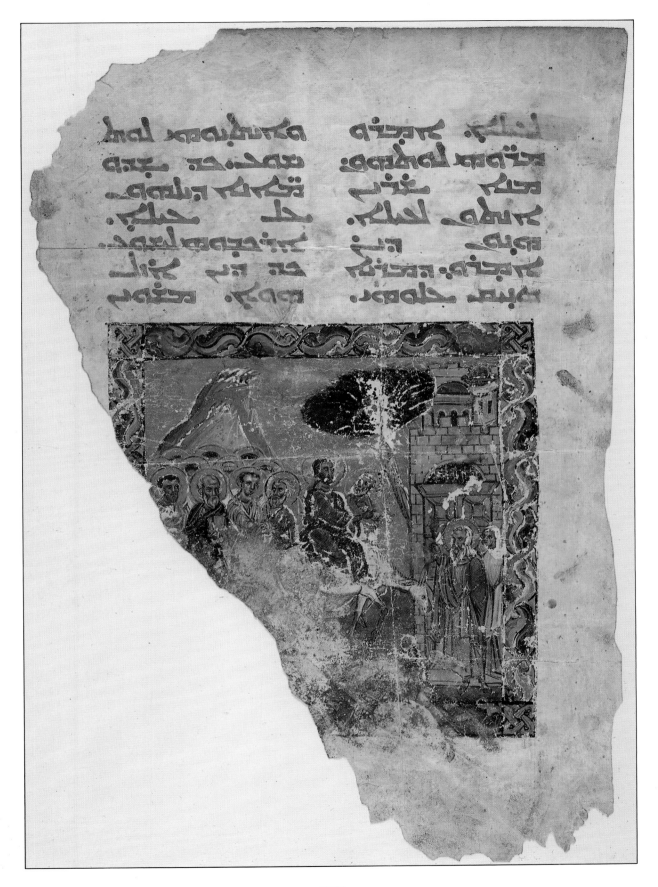

LEFT
Cat.8 Head of a Saint, said to have come from Syria, 10th century, fresco, 31 × 26cm (See page 51)

ABOVE
Cat.9 The Entry into Jerusalem, Syria, 12th century, parchment, 43.4 × 29.4cm (See page 53)

18

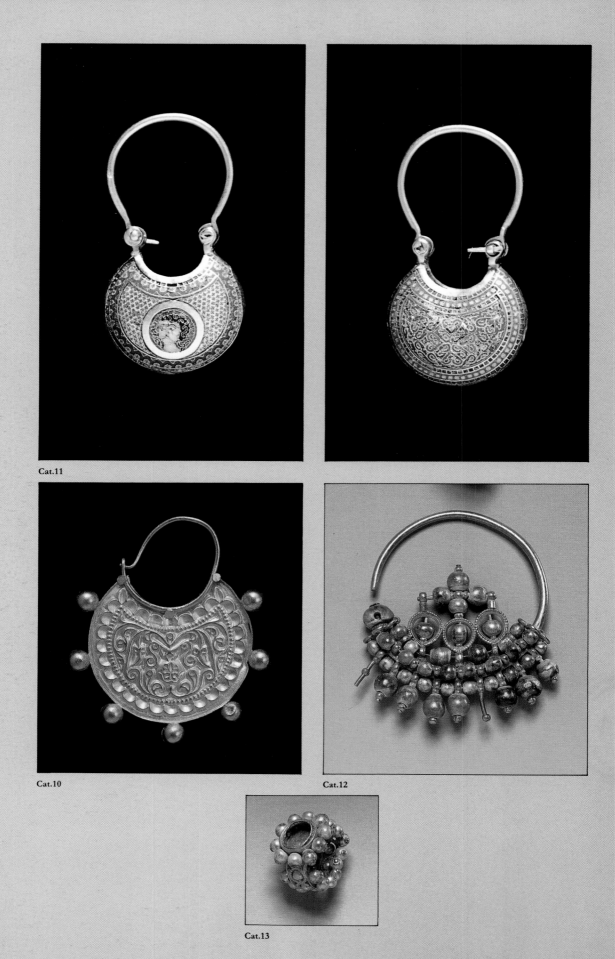

Cat.11

Cat.10

Cat.12

Cat.13

LEFT

Cat.11 Byzantine Earring, 10th–11th century, gold and enamel, 4.8cm (See page 56)

Cat.10 Lunate Earring, early Byzantine, 7th century, gold, 6.3 × 5.4cm (See page 55)

Cat.12 Byzantine Pearl Earring, 9th–10th century, gold and pearls, height: 7.2cm (See page 57)

Cat.13 Byzantine Finger Ring, 9th–10th century, gold and pearls, height: 2.4cm (See page 58)

BELOW

Cat.14 A Double-sided Pendant with Forty Saints, carved in steatite with a gold and *plique-à-jour* mount, Constantinople or Mount Athos, late 14th or early 15th century, 4.6 × 4.1cm (See page 59)

Cat.101 Gold Intaglio with Monogram, Byzantine, 6th–7th century, diameter: 1.3cm (See page 119)

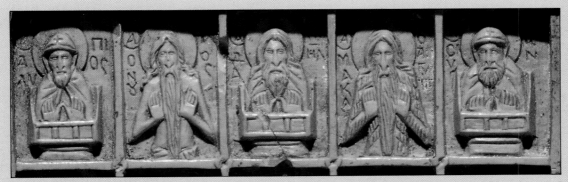

Cat.14 detail

Cat.14

Cat.101

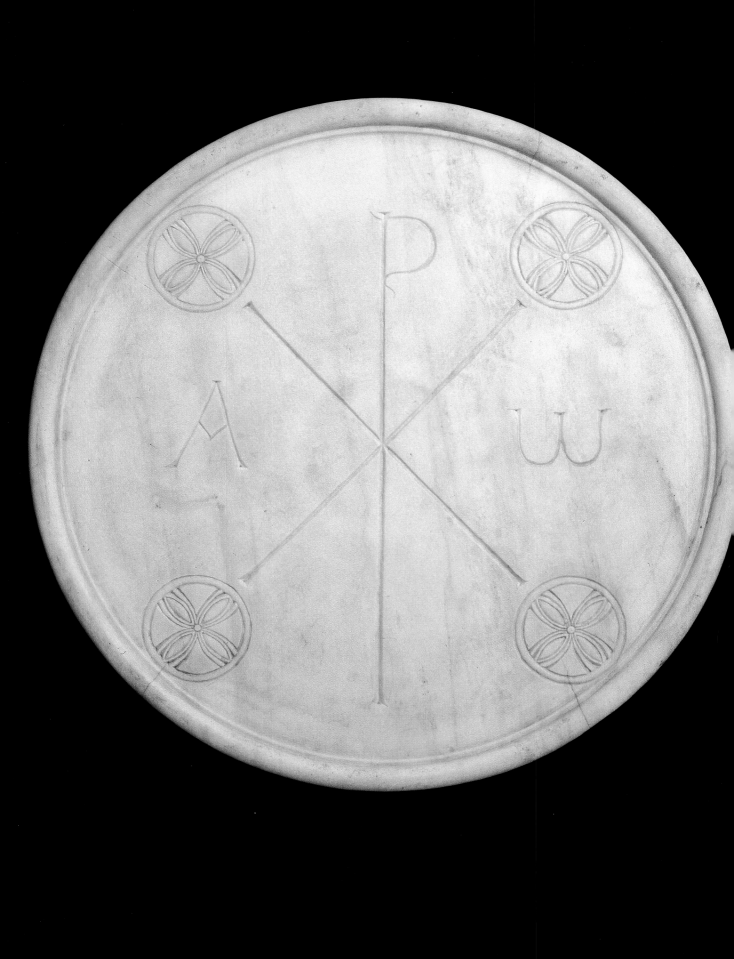

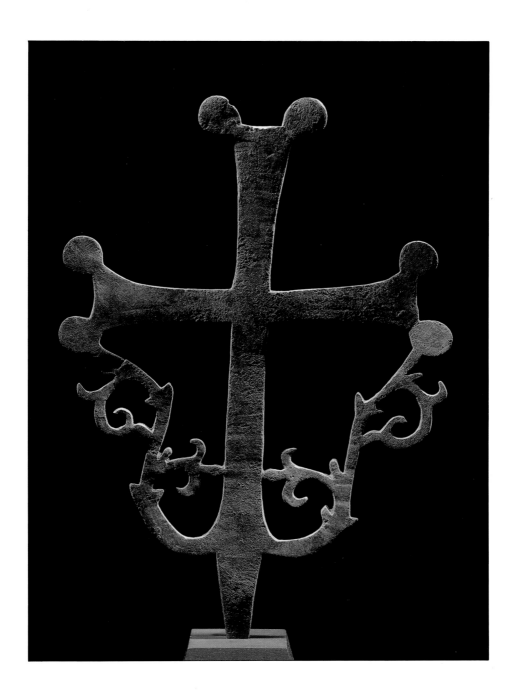

LEFT
Cat.15 Round Altar Table Top with Christogram, early Byzantine, 4th–6th century, marble, diameter: 124.5cm (See page 62)

ABOVE
Cat.65 Processional Cross with Foliate Scrollwork, Asia Minor, 11th–13th century, bronze, 45 × 28.5cm (See page 99)

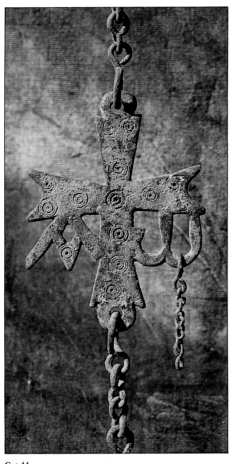

Cat.44

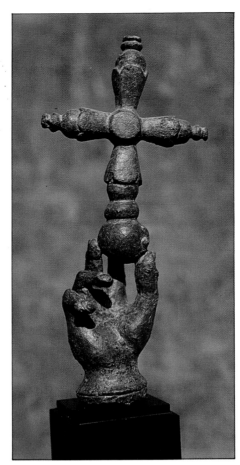

Cat.76

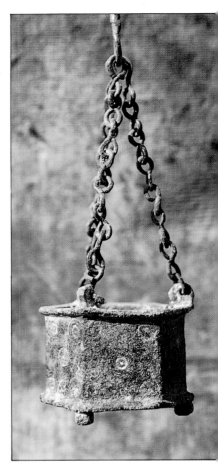

Cat.46

Cat.29

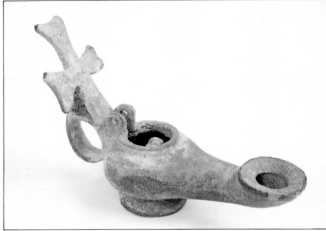

Cat.47

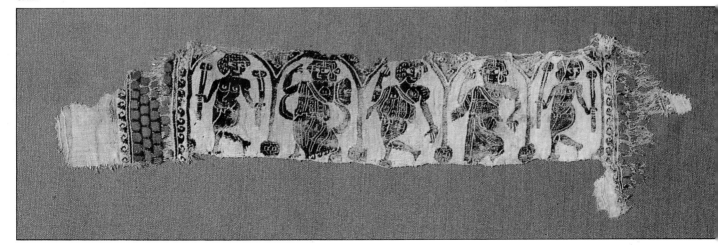

Cat.4

44 Chain from a Poly-
delon, Byzantine, 6th–7th
ury, bronze, length: 162cm
page 88)

76 Votive Hand with
ss, Palestine, 6th–7th century,
ze, height: 13.8cm (See page

46 Incense Burner, Syria,
century, bronze, width:
m (See page 89)

29 Oil Lamp, North
ca, 4th–5th century, ter-
tta, length: 14.4cm (See page

47 Lamp, Byzantine,
–7th century, bronze, length:
m (See page 89)

4 Textile Fragment, Egypt,
or 6th century, silk and
l, 8.3 × 45.5cm (See page 33)

PAGE

23 Tile, North Africa,
–6th century, terracotta,
32cm (See page 76)

26 Fragment of a Plate,
th Africa, 4th–5th century,

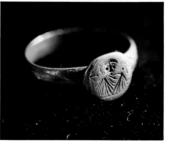

Cat.23

Cat.26

terracotta, length: 14.4cm (See
page 78)

Cat.93 Seal, Asia Minor,
976–1025(?), lead, diameter:
2.8cm (See page 115)

Cat.48 Reliquary Cross, Asia
Minor/Palestine, 6th–9th century,
silver, height: 9.4cm (See page
92)

Cat.54 Reliquary Cross, Asia
Minor/Palestine, 6th–9th century,
bronze, height: 9.8cm (See page
94)

Cat.96 Ring, Byzantine,
6th–10th century, silver, diame-
ter: 2.2cm (See page 116)

Cat.94 Seal, Asia Minor,
6th–7th century, lead, diameter:
2.5cm (See page 115)

Cat.67 Processional Cross, Asia
Minor/Palestine, 11th century,
bronze, 19.6 × 13.6cm (See page
102)

Cat.63 Thirteen Pendant
Crosses, Asia Minor/Palestine,
7th–8th century, bronze, height:
2.5–3.5cm (See page 98)

Cat.71 Processional Cross, Asia
Minor/Palestine, 9th–10th
century, bronze, height: 11.9cm
(See page 104)

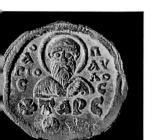

Cat.48 Cat.54 Cat.96 Cat.94

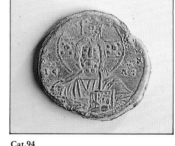

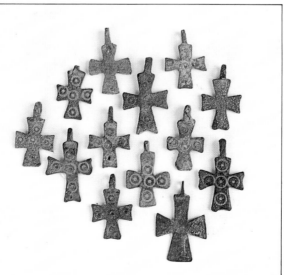

Cat.63

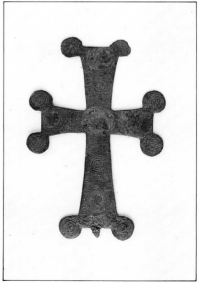

Cat.71

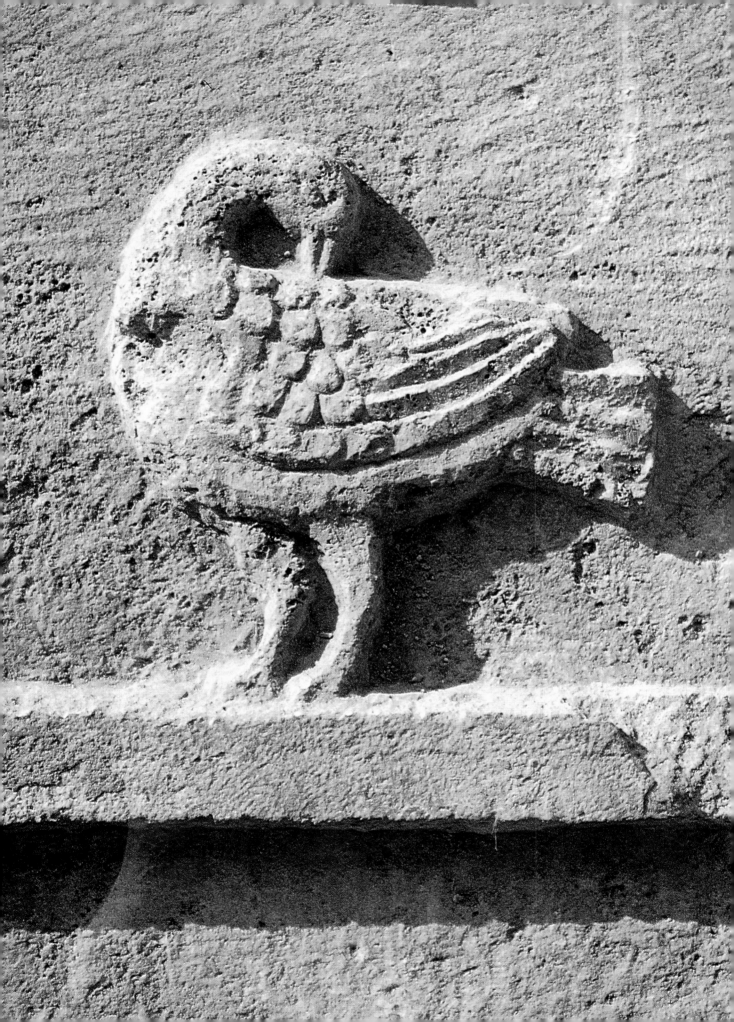

TEXTILES

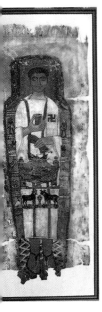

1. A Funerary Shroud
Depicting a Young Man
Egypt
c. AD 350
Tempera on linen
194 × 73 cm
Illustrated in colour on pages 9 and 10

The young man is shown full-length, framed by an open sarcophagus against which he is standing. He wears a plain white dalmatic, the simple tunic that came into fashion in the Roman Empire in the second century AD,[1] decorated with a reverse swastika on the left side of the chest.[2] Holding a beaker in his right hand and a folded cloth in his left, he regards the onlooker with an enigmatic and knowing smile. The painting conveys a sense of conviction seldom found in the more technically accomplished art of the Graeco-Roman period. The steadfast gaze, which is closely related to the Fayum portraits of the previous two centuries and to the earliest encaustic icons of the sixth and seventh centuries, is particularly striking. A similar example, though incomplete, is in the British Museum.[3]

This unusual funerary image testifies to the remarkable persistence of ancient Egyptian funerary practices. Work on the great Pharaonic temples had ground to a halt two centuries before, as Christianity replaced the doctrine that had prevailed for over three millennia. This was a transition that went relatively smoothly, since the Christian doctrines of Salvation and Resurrection were similar to (and quite possibly directly derived from) the main elements of the Osiris/Isis/Horus myth whose origins extend back deep into prehistory, antedating even dynastic Egypt itself. By the time this shroud was painted Christianity had become the official religion of the Roman Empire (AD 313) and, apart from a diehard contingent of priests still practising the rites of Isis at the island temple of Philae far to the south of Egypt, open practice of the ancient pagan ritual was outlawed and probably dangerous.

According to R. A. Schwaller, who developed the symbolist school of Egyptology, the obsessive attention lavished by Egypt on funerary procedures had a rationale. It was believed that, as long as the physical body existed, the disembodied soul (Ka) need not reincarnate. It remained free to wander the world at will and continue the process of spiritual transformation properly begun within this life on earth. The details of this process were set out in elaborate and mysterious fashion in the funerary texts. (In modern times these texts have acquired the name *The Egyptian Book of the Dead.*) It is interesting that a parallel understanding directs *The Tibetan Book of the Dead*, except that the Tibetans cremate the body, and allow just forty-nine days for the accomplishment of this posthumous spiritual process. In Egypt, by the fourth century

AD, the practice had been simplified and abbreviated; but the main elements can still be seen in place. Though stylistically the shroud has more in common with the Graeco-Roman and Coptic art of the period, the iconography is almost entirely ancient Egyptian.

The deceased, identified with Osiris, the mortal god who carries the seed of immortality (Horus) within him, is here portrayed in miniature as the mummified Osiris, wearing the white crown of the North and encircled by the protective wings of Isis and Nephthys: This representation is placed significantly over the genital area, for in the myth the dead Osiris, in the form of a bird, will magically fecundate Isis, who will in due course give birth to Horus. In more detailed form, this scene is portrayed as early as the thirteenth century BC in the Temple of Abydos, built by Seti I.

The other major participants in the myth, though not shown here in their actual roles, play them symbolically through their presence. Hathor, source of cosmic nourishment, who will protect the young Horus in the wilderness of the papyrus thickets (symbol of organic creation), is placed below the mummified Osiris. The registers, right and left, include the jackal-headed Anubis, who presides over embalming and who, in the form of Upuat, guides the disembodied soul through the purgatorial regions of the night that follows death. Thoth, shown as an ibis, traditionally records the verdict in the Egyptian Hall of Judgement. The Ba, the human-headed bird shown right and left, represents the spark of divinity inherent in every human being. In the Egyptian doctrine, the realised or divinised soul succeeds in uniting the Ba with the Ka (the complex of traits, desires and qualities that comprise the personality). He (or she) then becomes a star, joins the company of Re (pronounced Ra), and sails with him across the sky in his boat of millions of years. Horus, falcon-headed, carrying the Seth-headed staff of power, who will avenge the murder of his father, is also present.

In his right hand the deceased holds a beaker, thought to contain wine (not a traditional motif), but its mouth forms the glyph that spells Re, the solar principle. Re also means 'mouth', for Re created the world through the Word. In his left hand the deceased holds a piece of folded cloth whose significance remains unknown, though it is a common iconographic feature extending back to the earliest funerary reliefs of the Fifth Dynasty (circa 2400 BC).

<div align="right">J. A. W.</div>

Notes

1. *Encyclopaedia Britannica*, XIth edition, Vol. 7, p. 776. The example illustrated in pl. I has the same broad, vertical stripes as that worn by the figure in No. 1.

2, 'This graphic symbol is to be found in almost every ancient and primitive cult all over the world: in Christian catacombs, in Britain, Ireland, Mycenae and Gascony; among the Etruscans, the Hindus, the Celts and the Germanic peoples; in central Asia as well as in pre-Columbian America.' Cirlot, *Dictionary of Symbols*, London, 1962. See also René Guenon *The Symbolism of the Cross*, London, 1958, pp. 54–6: 'The *swastika* is essentially the "sign of the pole" . . . (it) is not a symbol of the world, but rather of the Principle's action on the world.'

3. T. G. H. James, *An Introduction to Ancient Egypt*, London, 1979, pl. 20.

APPENDIX

A technical analysis of the Egyptian shroud (catalogue no. 1) carried out in the studio of Laurence Morrocco

The image is of a young man or boy and is painted in a tempera technique on a thin layer of gypsum gesso, laid directly on to a fairly roughly woven piece of linen. The practice of wrapping the body in a shroud with an image of the deceased on it was much more commonly done with children than with adults. Also the use of tempera as a medium is absolutely consistent with a painted shroud. The portraits painted in encaustic or, more accurately in the case of Roman Egypt, wax technique, were almost exclusively painted on panels which were fitted to the coffins. The painted shrouds were wrapped directly around the bodies.

There are several places on the shroud showing horizontal distress lines in the paint surface, suggesting that the shroud was folded or rolled up at some time. There are four horizontal cuts or tears in the cloth. It is difficult to know exactly why this has been done, but it appears to be deliberate.

The major damage to the cloth is at the bottom and the fringed edge has been lost.

The paint itself is generally in good condition and, after examination by stereo microscope and pigment tests, it is clear that the only significant additions are in the recent application of titanium white to give body to some of the more damaged areas of the white robe and to highlight various places over the painted surface. Titanium white is a modern pigment first used in 1916. At first sight it appears that there may have been some repainting on the face, since the colour of the flesh on the hands and neck is much lighter in tone than on the rest of the face. The feet are also the same colour as the face.

However, on closer examination, it appears that there is no difference in the character of the paint, and the pigment analysis shows that the paint samples taken from points 4, 5 and 6 on the diagram (see fig. 2) are identical except for the addition of gypsum in sample 4.

Gypsum has been used as white by the painter to obtain a lighter hue of the flesh colour. It would seem that this is a fairly crude attempt at applying highlighted areas to the neck, and not a later addition. I expected the blue to be either Egyptian blue or indigo. Indeed, initial tests showed the colour to be indigo. However, because the blue pigment was very finely divided (most particles being less than one micron across), this suggested that the pigment might be precipitated, such as Prussian blue, a modern (eighteenth-century) colour. Indigo and Prussian blue are pigments of similar colour, but indigo is not precipitated; it is ground directly into a fine powder from the organic material indigotin. So, in order to differentiate between indigo and Prussian blue, several microchemical tests were performed on the blue pigment.

The first test showed that the blue pigment dissolved in hot dimethyl formamide. This indicated that the blue pigment may be organic in origin. A second microchemical test was performed and repeated several times.

First, the pigment sample was immersed in a single drop of hydrochloric acid (dilute), after which no change in the pigment was noted. The sample was then dried

and a drop of dilute sodium hydroxide was placed over the specimen. Again, no colour change was noted, suggesting once again that the blue pigment was not Prussian blue. Prussian blue would have changed into a brown pigment. The sample pigment was again dried, and to it was added a single drop of dilute nitric acid and the preparation warmed. The blue disappeared and a yellow was formed, indicating the presence of indigo. This test produced consistent results each time it was performed.

As a control test, a minute quantity of Prussian blue was treated in the same manner and this gave a positive result for Prussian blue.

I had initially thought, after the preliminary visual examination, that the light yellow colour found in many areas of the paint surface had been added to at some time. Closer examination by stereo microscope, however, showed this not to be the case. The pigment itself was identified as orpiment (arsenic yellow), a colour totally consistent with Roman Egyptian painting.

There are several areas where small patches have been applied to the shroud presumably to mend tears and holes in the fabric. These repairs have been tinted with colour to match the original paint. I felt it necessary to test the pigment from one of these patches and to compare it with the surrounding paint. If the two pigments were the same, it might pose questions as to the authenticity of the shroud.

Although I had no personal doubts as to its authenticity, it was important that this test should be done.

As expected, the results were quite conclusive, the colour on the repairs being quite different from the colour surrounding it. In fact, the colour on the patches seems

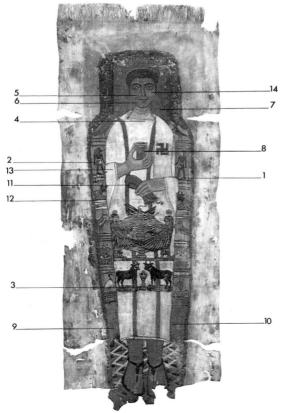

Fig.2

to be some kind of organic dye such as saffron but it is very difficult to identify as there are no obvious pigment particles visible.

I did not feel it necessary to test the other earth colours or the black as it would be most unlikely to find a modern synthetic amongst them. This is because the source of these pigments has not changed for thousands of years and, as a result, they are as common today as they were in ancient times.

Identification of Pigments

The technique

Samples of pigment were taken from fourteen sites on the paint surface. These sampling sites are indicated on the diagram. The pigment samples were removed using a fine-pointed tungsten needle while viewing the paint surface under a stereo microscope. The pigment samples were then mounted on a glass microscope slide using Arochor 5422 which is a thermosetting resin with a refractive index of 1.66.

Each sample was dispersed within the mounting medium and examined using a polarising light microscope at magnifications of between $100 \times$ and $800 \times$. In order to identify the pigments, comparisons were made using previously prepared standards of known pigment types.

The results

Sample 1
From repaired patch right of god Horus organic dye? (saffron?) (no discrete pigment particles found)

Sample 2
From top left border panel depicting god Seth orpiment (arsenic yellow)

Sample 3
From top of altar between two bulls orpiment

Sample 4
From neck of main figure red ochre + gypsum

Sample 5
From cheek of main figure red ochre + yellow ochre

Sample 6
From just below sample 5 red ochre + yellow ochre

Sample 7
From blue background next to right ear of main figure indigo on a yellow ochre base

Sample 8
From cup held in hand of main figure indigo

Sample 9
From blue on bottom left background indigo

Sample 10
From blue on bottom right background indigo + yellow ochre

Sample 11
From purse held in hand of main figure madder

Sample 12
From necklace on bull second top left
panel titanium white

Sample 13
From left sleeve of main figure gypsum

Sample 14
From right eye of main figure gypsum

All the pigments identified, except no. 12 (titanium white), have been used from the earliest times.

<div align="right">L. M.</div>

2. & 3. 'Spring' and 'Summer'
Two textile panels, each depicting a female figure
Egypt, possibly Alexandria
Late 4th or early 5th century
All wool, tapestry weave,
24.8 × 26 cm and 24.6 × 25 cm
Illustrated in colour on pages 11, 12 and 13

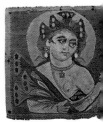

Cat.2

'Spring' is shown half-length; her head, slightly inclined and following her gaze, is turned to the right. The left hand is raised and holds a fold of her drapery so as to expose her naked left shoulder and breast. In the crook of her right arm she carries three lotus plants and her hair is dressed with a wreath of lotus pods. She wears a necklace and pendant earrings. She is obviously a very young women, full-bodied and brimming with youth and health. At the same time, as well as being richly gifted by nature, she is endowed with attributes of divinity. Some of these attributes, such as the halo, the seed pods, and the partial nakedness, are no more than iconographical conventions; but the artist has succeeded in penetrating the psychological level that lies behind the convention and without which the imagery would be mere routine. Thus we sense, in the half-smile and in the longing look, the power that invests human nature with divine grace.

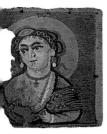

The imagery of 'Summer' mirrors the composition of her companion, though here, in the crook of her left arm, she holds ears of barley and, between the thumb and finger of her left hand, an indistinct object that may be a fruit or a nut. She wears a similar necklace and earrings but her hair is more elaborately coiffured with a jewelled diadem. She is also a young woman, though her face expresses more maturity than 'Spring'. The heavy shading under the eyebrows gives her a more pensive look. Again, it is possible to feel that the material person is somehow transparent, allowing us to feel the immanence of a higher and infinitely benign power.

Colour is employed with great richness and subtlety. For example, the flesh tones in the face of 'Summer' are made up of five different tones of pink, while four differing shades of brown are used for shading. These mostly pale colours are directly juxtaposed so as to achieve an impasto effect, the individual colours of which can be seen at very close quarters but which, as in impressionist painting, blend into natural shades when viewed from farther away. The work is never repetitive and quite different colours are employed for each face; for example, the lower lids of 'Spring's' eyes are outlined in blue and this gives her look a soft, clear-eyed sparkle that is rather different from 'Summer's' more introspective reverie. The weaver is an artist of advanced faculties and has highly developed intuitive responses to each deity personified. It is surely this quality, rather than an intellectual contrivance, that guides his (or perhaps her) artistry.

Both figures have haloes of sandy, golden yellow and narrow borders in the same colour. The ground is a smoky sky blue.

R. C. C. T.

We have consulted Hero Granger-Taylor who has kindly written the following:

The very subtle shading is achieved not only by careful ordering of the threads but by the pairing of threads of different colours and by mixed spinning, that is, the combination in one yarn of dyed fleece of different colours.

There are ten to fifteen warp threads per centimetre and thirty-five to seventy single weft threads per centimetre. The spin direction is 'S' almost throughout; it seems that the only 'Z' spun yarn is one of the browns used for hair. The panels would have been woven as part of a much larger textile whose function we do not now know. The dark bluey-purple of the warp threads, which are just visible at the upper and lower edges of the panels, probably indicates its main colour.

Within the historical range of Coptic textiles these are relatively early. The evidence for this is the naturalism of the classical pose and, more particularly, the delicate colouring and shading. However, the strong lines above and below the eyes and the heavy shadows in the drapery suggest a date no earlier than the Late Antique period. One detail is helpful here: the earrings, consisting of a pendant pearl below a gold cube containing a jewel or enamel, are of a type that was not common before the fourth century.

There are several reasons for supposing that the panels were woven in Egypt. One is that they were almost certainly found there. 'S' spinning is typical of Egypt; also convincing is the presence of the lotus plants in the 'Spring' panel. The flower of the

Egyptian and Asiatic lotus, a type of water lily, *Nymphea lotus*, was a common feature of Egyptian art from very early times; and in the Roman period the lotus seed-head became a kind of shorthand for Egypt and the Nile. The seed-head is hemi-spherical with round holes in the flat top, and it is mainly these seed-heads with their holes that are represented on the tapestry here. Three flowers are also shown but these, still in the form of narrow pink buds, are less obvious.

At first it is tempting to see ripe corn as the attribute of Autumn rather than Summer. But in such a southerly latitude Summer does actually make more sense. In the British Museum there is a fourth-century mosaic fragment from Carthage showing the months and seasons.[1] Here Summer is also shown with ears of corn which, in this case, she wears as a wreath on her head.

A third season represented on a tapestry panel, which was in Vienna in the Figdor Collection in 1930, must be from the same set as the Temple Gallery's 'Spring' and 'Summer'.[2] This is in very similar style and is of the same size; it has the same blue ground and even has the same dots around the border which may be rust marks caused by nineteenth-century pins. Before its acquisition by Figdor this panel had belonged to Graf, also of Vienna, and it seems very likely that 'Spring' and 'Summer' were also once part of the Graf collection. Graf had a large collection of Coptic textiles which he had acquired through excavations run by himself in the Fayum region of Egypt, at a location he kept secret.[3]

The Figdor personification holds a sash full of fruit and wears a wreath of what appear to be pomegranates. If alone, this fruit-bearing figure would be identifiable as Earth; but in a set with other personifications she must be Autumn.[4] We do not know the present whereabouts of Winter and this panel may not have survived into modern times. If she conformed to the type seen in surviving works (such as, for instance, the Seasons mosaic from Antioch) she would have been well wrapped up with her mantle over her head and set against or carrying bare twigs.[5]

The theme of the Seasons, like the closely related themes of Earth and Ocean, is common in late Roman and early Byzantine art. Although essentially pagan, it was not seen as anti-Christian. It was employed most commonly in mosaic and, as such, is found in early church decorations.[6]

Among surviving textiles, an obvious parallel is with two small round tapestry panels in the Louvre, each with a woven inscription in Greek identifying the female busts respectively as 'Wintertime' and 'Springtime'.[7] More similar in style, however, are two embroidered Coptic panels belonging to the Manchester University Museum, unpublished but at present on display in the Whitworth Art Gallery. These Manchester panels, showing Autumn and Winter, must again be part of what was once a set of four Seasons. Autumn is exceptionally beautiful and, with her inclined head and gentle look, is a close cousin of the 'Spring' and 'Summer'.

<div align="right">H. G.-T.</div>

Provenance
1. Graf Collection
2. Ikle Collection

Notes

1. R. P. Hinks, *Catalogue of Greek, Etruscan and Roman Paintings and Mosaics*, British Museum, London, 1933, nos. a–h.

2. *Die Sammlung Albert Figdor, Wien*, ed. Otto von Falke, Vienna, 1930, vol. 1, no. 2, pl. l.

3. J. Karabacek, *Katalog der Theodor Graf'schen Funde in Aegypten*, Österreichisches Museum, Vienna, 1885.

4. Henry Maguire, 'The Mantle of Earth', *Illinois Classical Studies*, XII, 2, 1987, pp. 221–8. Hero Granger-Taylor, 'The Earth and Ocean Silk from the Tomb of St Cuthbert at Durham; Further Details', *Textile History*, XX, 2, 1989, pp. 157–60, especially note 38.

5. Doro Levi, *Antioch Mosaic Pavements*, Princeton, 1947, pp. 226ff. and pls. 52ff. See also male 'Winter' in mosaic at Chedworth, England – Joan Liversidge, *Britain in the Roman Empire*, London, 1968, fig. 40.

6. Ernst Kitzinger, 'Studies on Late Antique and Early Byzantine Floor Mosaics: I, Mosaics at Nikopolis', *Dumbarton Oaks Papers*, VI, 1951, pp. 83–122.

7. Pierre du Bourguet, *Musée National du Louvre: Catalogue des Etoffes Coptes*, 1, Paris, 1964, B 25 (note the assemblage of panels and stripes is not original).

,4 detail

4. A Textile Fragment
Depicting Figures in a Ritual Dance
Egypt
5th or 6th century
Silk, and wool, tapestry weave
8.3 × 45.5 cm
Illustrated in colour on page 22

Five crisply drawn dancers, placed within arches, evoke an atmosphere of antique rhythm and festivity. The imagery calls to mind a line from Keats: 'Heard melodies are sweet, but those unheard are sweeter' (Ode on a Grecian Urn). The two female figures, in long flowing robes, glance seductively at the men to their right who happily return their look. The two outermost figures hold what appear to be either torches or percussion instruments. The dancers could be part of a nocturnal procession winding its way through the streets of Alexandria. Perhaps they were celebrating the cult of Dionysius which was widespread and popular in Hellenistic Egypt. Dionysius – the Roman Bacchus – had become identified in earlier times with the Egyptian god Osiris, and the Christians found similarities between him and Christ. Both had a mortal mother and a divine father; and both were associated with virtue of one kind or another, thereby exemplifying the extraordinary religious synthesis of the period.

This delightful fragment can be categorised as a Coptic textile – if we use the term in its broadest context. The stylistic treatment of the figures is strongly Hellenistic while the architectural forms are suggestive of Byzantium. Its likely function was as a decoration on the borders of a tunic.[1]

J. H.

Note

1. For comparable examples see *Textiles from Egypt*, L. A. Mayer Memorial Institute for Islamic Art, 1980, p. 71, no. 80 and Pierre du Bourguet, *Catalogues des Etoffes Coptes*, vol. 1, Editions des Musées Nationaux, Paris, 1964.

METALWORK

5. Bishop Paul's Paten

Byzantine
6th or 7th century
Silver gilt
Weight: 1600g; diameter: 46 cm
Illustrated in colour on page 14

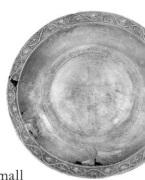

Cat.5

At the centre of this large silver paten is an engraved Latin cross which has small spherical projections, known as serifs, at the tips of the arms. Numerous examples of this type of cross are found in Byzantine art, for instance: a sixth- or seventh-century silver cross from Phela;[1] a large cross on Mount Sinai;[2] a cross in the Istanbul Archaeological Museum;[3] and a sixth-century paten in the Hermitage.[4]

Between engraved lines, a circular band 1.9 cm wide bears a Greek inscription, ✝ ΚΥΡΙЄ ΜΝΗϹΘΗΤΙ ΠΑΥΛΟΝ ΤΟΥΑΜΑΡΤΟΛΟΝ ЄΠΙϹΚΟΠΟΝ ✝ , 'O Lord Remember Bishop Paul a Sinner', from which we may infer that the paten was given by Bishop Paul to a church or monastery. A meandering vine, laden with grapes, decorates the paten's rim. Here the ornamentation, on a band 3.9 cm wide, is set between two raised lines. This ornamentation, and also the cross and the background to the inscription, are gilded.

On the reverse can be seen a control stamp. Unfortunately this is rather rubbed and cannot be deciphered. The only readable letter is 'N', its form has no analogy among the known Byzantine control stamps.[5] Patens of Constantinopolitan origin usually have several stamps, among which is the emperor's monogram, and these allow us to date them and attribute them precisely.

The style of the inscription, in particular the palaeography with its characteristic serifs, has many analogies among objects of applied art between the fifth and the seventh centuries found in Syria and Palestine. Similarities of writing style, with letters made of thin, single strokes, can be seen on the cross at Mount Sinai,[6] in patens in the Walters Art Gallery[7] and elsewhere. Analogies for the inscription, particularly the form of the letters 'A', 'P', 'Є', 'Π' and 'O', are found among objects of applied arts in silver of the sixth and seventh centuries. Examples of these are a Byzantine buckle plate and a Syrian chalice in the British Museum, a paten and a cross both in the Walters Art Gallery.[8]

Fig.3

Fig.4

The paten at the Temple Gallery differs from most known examples in its inscription and in the decoration on the rim. The latter can be compared with decoration on two plaques from the Antioch Treasure in the Metropolitan Museum in New York.[9] Some motifs from this ornamentation can be seen on seventh-century plates from the Dumbarton Oaks Collection and also in the Hermitage,[10] on the repoussé silver plates of the ivory Triptych of Philoxenus, dated AD 525, in the Cabinet des Médailles in Paris[11] and on the marble capitals in the Istanbul Archaeological Museum dated AD 540.[12]

Thus our paten's composition, ornamental features and characteristic palaeography allow us to include it among the group of Byzantine objects in silver whose date is established in the sixth century or, in some cases, the seventh century.

Further to the points of difference with known patens of similar date, such as its decorated rim which is found in only one other example, we should consider its unusual size and weight. With few exceptions other known patens are smaller. The following table of weights and diameters of patens from the Kaper Koraon Treasure (excavated at Stuma in 1908)[13] shows the comparison:

reference	diameter	weight
Mango no. 4	39 cm	987 g
Mango no. 5	37.6 cm	1008.1 g
Mango no. 6	40.8 cm	1000 g
Mango no. 34	36 cm	1090 g
Temple Gallery no. 5	46 cm	1600 g

Taking into account the craftsman's high technical ability, together with the paten's weight and size, we can justifiably suppose that the donor, the Bishop Paul who is named in the inscription, was a man of considerable substance and it is likely that his paten was intended for a church or cathedral in one of the major centres of the Byzantine Empire in the sixth or seventh century. It is interesting to note that the Patriarch of Alexandria from AD 539–41 was called Paul.

The closest analogy to our paten is the paten of Bishop Paternus in the Hermitage. It has similar ornamentation on its rim and it is dated to the sixth century.[14]

Hero Granger-Taylor has noticed a grained pattern on parts of the paten's surface. She suggests that the paten was buried – perhaps during several centuries – wrapped up in a textile. Oxidisation would have caused the cloth to fuse with the surface of the silver, resulting in the pattern we now see.

Microanalysis of the silver is included below (see appendix on page 36).

N. K.

Notes

1. M. M. Mango, *Silver from Early Byzantium*, Walters Art Gallery, Baltimore, 1986, no. 65.

2. K. Weitzmann and I. Ševčenko, 'The Moses Cross at Sinai', *Dumbarton Oaks Papers*, no. 17, Washington, 1963, no. 1.

3. M. M. Mango, op. cit., no. 8.

4. A. Bank, *Vistaniyskoe Iskusstvo V Sobraniach Sovetskogo Sojza*, Moscow, 1977, vol. 1, no. 154.

5. See E. G. Dodd, 'Byzantine Silver Stamps' in *Dumbarton Oaks Studies*, no. VII, Washington 1961; M. Rosenberg, *Der Goldschmeide Merczeichen*, Berlin, 1928; M. M. Mango, op. cit.

6. K. Weitzmann and I. Ševčenko, op. cit.

7. M. M. Mango, op. cit., no. 4 and no. 6.

8. Ibid., nos. 4 and 7.

9. Ibid., nos 44 and 45.

10. E. G. Dodd, nos. 39 and 51.

11. D. Talbot Rice, *The Art of Byzantium*, London, 1959, no. 30.

12. Ibid., no. 33.

13. M. M. Mango, op. cit.

14. A. Bank, op. cit., no. 142.

APPENDIX

Analysis and Metallography of a Byzantine Silver Paten

A sample cut from a Byzantine silver paten of approximately sixth-century AD date was submitted by the Temple Gallery. The sample was mounted in a copper-filled acrylic resin, ground and polished. Analysis was by electron-probe microanalysis using the CAMEBAX automated instrument in the Department of Materials, University of Oxford. An optical metallographic examination was also made with the sample as polished and then etched. The etch used was a solution of potassium dichromate, acidified with sulphuric acid with a small amount of hydrochloric acid added immediately before use.

Each individual analysis was carried out over an area of 50µm square. Advantage was taken of the relatively large sample size to make repeat analyses to determine how homogenous silver alloy sheet of this type might be. In all 32 analyses were made. The individual analyses, means and standard deviations are given in the attached table. Taking 'silver' to represent silver + lead + gold, the last two elements being impurities that came into the alloy with the silver, the paten is made from an alloy of approximately 95.2 per cent silver and 4.8 per cent copper. Although silver alloy standards for plate varied considerably with time in the ancient world a composition such as this is very common.

At this time silver was generally produced by extracting it from lead ores and refining it by cupellation. This process ensured that any gold which was present was concentrated in the silver while some lead inevitably remained in solution in the silver. Silver recovered from silver alloy scrap was also refined in the same way and the same impurities would remain. The levels of other impurities are generally low and their distribution rather random. The paten contains 0.53 per cent lead and 0.67 per cent gold, both typical values for a wide range of ancient silver.

Metallography

The sample was mounted so that a corroded surface was uppermost. Initial grinding removed some of the corrosion exposing sound metal and the sample was analysed at this stage. The corroded areas showed patches of silver-rich corrosion products with the attack extending intergranularly into the sound metal. After analysis the sample was re-ground and re-polished to a depth where all corroded patches visible to the naked eye were removed. Examination under the optical microscope showed that small patches of intergranular attack remained.

The sample was then etched and examined again. Copper is much more soluble in silver at high temperatures than at low and the $\simeq 5$ per cent copper in this alloy exceeds the limit of solid solubility of copper in silver. However, when silver is cast the cooling rate is generally sufficiently fast for it to be impossible for all the copper content of the solid solution to be reduced to its equilibrium value. The solid solution is said to be supersaturated and is ultimately unstable. The process of working and annealing might remove some copper from solution but the silver when deposited in the ground would

still be saturated with copper. Over archaeological time the excess copper will gradually precipitate out by a process known as discontinuous precipitation, typically at the grain boundaries of the original microstructure. The resultant microstructure is very recognisable and a good indicator of age. It was observed very clearly in this piece.

Thus, the combination of a typical composition for an ancient silver alloy and a miocrostructure showing the characteristic features of discontinuous precipitation strongly support the authenticity of the paten. The corrosion structure is less diagnostic but it is also consistent with the proposed date.

Composition in Weight Percent of a Sample from a Byzantine Paten, Tlaha 63

	Fe	Co	Ni	Cu	Zn	As	Sb	Sn	Ag	Bi	Pb	Au	S
1	.	0.01	.	5.20	0.12	.	0.01	.	93.39	0.06	0.56	0.63	0.01
2	.	.	.	4.80	0.01	.	.	.	94.09	.	0.49	0.59	0.01
3	0.01	.	.	4.95	0.08	.	.	.	93.72	.	0.54	0.61	0.09
4	0.01	.	.	4.89	0.03	0.21	.	.	93.61	0.03	0.56	0.65	0.02
5	.	.	.	4.44	0.02	.	0.01	.	94.26	0.03	0.59	0.65	.
6	.	.	.	5.24	0.06	.	.	.	93.27	0.19	0.58	0.66	0.01
7	0.01	0.01	0.04	4.37	0.09	.	.	.	94.02	0.10	0.58	0.77	0.02
8	.	.	.	4.61	0.13	.	.	.	93.92	0.07	0.44	0.84	.
9	.	.	.	4.46	0.01	.	.	.	94.29	0.03	0.55	0.66	.
10	.	.	0.01	4.66	0.07	0.29	.	.	93.74	0.02	0.55	0.66	.
11	0.01	.	0.02	4.84	0.12	.	0.02	.	93.83	0.02	0.50	0.63	.
12	.	.	.	5.32	0.11	.	.	.	93.29	0.07	0.53	0.67	0.01
13	.	.	0.02	4.94	0.09	.	.	.	93.68	0.04	0.59	0.65	.
14	.	.	0.02	5.40	0.03	0.31	.	.	93.05	0.06	0.48	0.65	.
15	0.01	0.02	.	4.85	0.05	.	.	.	93.83	0.08	0.57	0.56	0.02
16	.	.	.	4.85	0.04	.	.	.	93.98	.	0.50	0.62	0.01
17	0.01	0.04	.	5.02	0.01	.	.	.	93.58	0.08	0.65	0.62	0.01
18	0.02	.	0.03	4.59	0.09	0.29	.	.	93.78	0.04	0.48	0.65	0.02
19	0.01	0.02	.	4.66	0.11	.	.	.	94.03	0.05	0.45	0.63	0.03
20	0.01	.	0.03	4.57	0.02	.	0.01	.	94.12	0.03	0.53	0.67	0.01
21	.	0.01	.	4.67	0.08	.	.	.	93.90	0.02	0.59	0.71	0.02
22	.	.	.	5.19	0.09	0.23	.	.	93.18	0.10	0.52	0.66	0.03
23	0.01	.	.	4.63	0.01	.	.	.	94.05	0.03	0.57	0.70	0.01
24	.	.	0.01	4.94	0.07	.	.	.	93.58	0.07	0.59	0.73	.
25	0.02	0.01	0.01	4.47	0.08	.	.	.	94.19	0.02	0.44	0.75	0.01
26	0.02	0.01	0.01	4.78	0.04	.	0.01	.	93.95	0.04	0.48	0.66	.
27	.	.	0.03	4.87	0.07	.	0.01	.	93.86	0.02	0.52	0.62	.
28	0.02	.	0.01	5.03	0.06	.	.	.	93.77	.	0.49	0.62	0.01
29	.	0.02	.	4.94	0.06	.	.	.	93.65	0.03	0.59	0.70	0.01
30	.	0.01	0.01	4.99	.	0.51	.	.	93.19	0.10	0.47	0.70	0.02
31	.	0.02	.	4.72	0.07	.	.	.	93.89	0.10	0.53	0.65	0.02
32	.	.	0.02	4.86	0.05	.	.	.	93.58	0.17	0.55	0.77	.
Mean	0.01	0.01	0.01	4.84	0.06	0.06	.	.	93.76	0.05	0.53	0.67	0.01
Standard deviation	0.01	0.01	0.01	0.26	0.04	0.13	.	.	0.32	0.04	0.05	0.06	0.02

Limits of detection are 100–200ppm for all elements except gold, 300–400ppm, and arsenic 400–600ppm.

Elements analysed are: iron (FE), cobalt (Cu), zinc (Zn), arsenic (As), antinomy (Sb), tin (Sn), silver (Ag), bismuth (Bi), lead (Pb), gold (Au), sulphur (S).

Dr J. P. Northover
C. J. Salter

6. Gold Repoussé Plaque with Iconic Scenes

Byzantine
6th century
8.6 × 4.5 cm
Illustrated in colour on the back cover

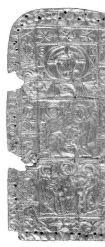

Cat.6

The plaque is surrounded by an ornamental double border and is horizontally divided into three panels, each of which is framed by a beaded line. The upper register features the bust of Christ with a cruciform halo and the inscription EMMANUEL (four letters on each side of the bust). In the centre there is an Annunciation with the Mother of God on the left and the Archangel Gabriel on the right, both nimbed. The accompanying inscription reads: 'Hail, O favoured one, the Lord is with thee . . .', taken from Luke 1, 28. In the lower panel, the Virgin and Child on a cushioned throne, attended by two angels, are shown. There is no inscription added to this last scene, but there are two six-pointed stars to each side of the head of the Mother of God. Again, each of the figures is nimbed.

Framing the composition is an inner border of twelve small panels, each one containing the bust of a bearded apostle in profile. Each panel is surrounded by beaded or rope-like lines. Three eight-pointed stars fill the upper horizontal part of the border. These correspond to foliate motifs in the lower horizontal part. The outer border consists of a line of punched beading. Small holes along the outer edge suggest that the plaque was sewn on to clothing. Aimillia Yeroulanou, writing in the *Journal of the Walters Art Gallery* (1988), describes a gold openwork ornament of the sixth century, in the collection of the museum. She points out that such objects were worn as protective charms. In some circles, the first word of Gabriel's salutation to Mary at the Annunciation, 'Hail', was used as an invocation to health and wholeness.[1]

The short curly hair of Christ, together with the fact that he is beardless, are characteristic of the earlier Hellenistic type of imagery that later gave way to the bearded, long-haired visage with which we are more familiar. The cruciform halo, which was to become a regular feature of later representations of Christ, rarely occurs in early Byzantine works of art. Its mid-sixth-century use is, however, attested by a Justinian silver reliquary in the Hermitage Museum.[2]

The unusual representation of the Annunciation with the Virgin on the left and the Archangel on the right is also suggestive of a sixth-century date. In later iconography these positions are usually reversed. The present arrangement is characteristic of examples from Syria, Palestine and Constantinople between the third and sixth centuries.[3]

In contrast to the vivid narrative scene of the Annunciation, the symmetrical representation of the Virgin seated frontally in the centre, holding the Christ-child on her lap, and of the two flanking angels, presents a hieratic image of majesty. The arrangement of the three different panels in this way is not coincidental. It reflects a theophanic vision of Christ's Second Coming combined with the image of the Mother of God as the instrument of his Incarnation and the moment of the Annunciation.

In spite of the cursory style which is characteristic of figural decoration on early

Byzantine goldwork, it seems likely that the representations on this gold plaque were derived from major works of art. The slightly arched upper edge recalls the architectural settings of diptychs and early icons. The figures are well proportioned, the drapery falls in soft, naturalistic folds. The stability of the frontal representation of the Virgin, in contrast to the slight movement of the angels shown in profile, creates a certain liveliness in both scenes which indicates a classicism still prevalent in early Byzantine art. At the same time, the majestic figures of Christ in the top register and of the enthroned Virgin in the lower one enhance the iconic quality of the plaque.

Pictorial representations of Christian, imperial or mythological subjects are a characteristic feature of Byzantine goldwork during the sixth and seventh centuries. The present plaque can be related to a group of circular gold pendants. Points of comparison include the repoussé technique and the arrangement of scenes from the life of Christ in registers, with additional inscriptions. A large medallion from the second Cyprus hoard features the Virgin and Child attended by archangels as well as the Nativity and the Adoration of the Magi.[4]

A second pendant from the Assiut treasure depicts the Annunciation on one side and the Miracle of Cana on the other.[5] Two identical medallions in the Archaeological Museum in Istanbul are of special interest here as not only do they display a full range of events from the New Testament, but they also have busts of the apostles as border ornament.[6] A further related medallion with an Annunciation was found in an early-seventh-century grave in Turunuelo in Spain.[7]

Like the gold plaque these pendant medallions are splendid examples of the narrative art of Byzantium in the sixth and seventh centuries and they demonstrate the immense influence that religious ideas had even on articles of luxury. None of the pendants, however, betrays the quality of composition, the generous rendering of the single figures or the distinct iconic character of the gold plaque.

B. D.-L.

Notes

1. See André Grabar, *Christian Iconography: A Study of its Origins*, London, 1969, p.98.

2. H. Buschhausen, *Die Spatromischen Metallscrinia und Fruhchristlichen Reliquiare*, Wiener Byzantinische Studien 9, 1971, pp. 252–4, no. B.21; A. Bank, *L'Art Byzantine*, 1985, fig. 77.

3. G. Millet, *Recherches sur l'Iconographie de l'Evangile*, Paris, 1916, pp. 68–77.

4. M. C. Ross, *Catalogue of the Byzantine and Early Mediaeval Antiquities in the Dumbarton Oaks Collection II*, Washington, 1965, no. 36; K.Weitzmann (ed.), *The Age of Spirituality*, New York, 1977, no. 287.

5. Weitzmann, op. cit., no. 296.

6. See D. Talbot-Rice, *The Art of Byzantium*, London, 1959, no. 66; Grabar, op. cit.

7. H. Schlunk/Th.Hauschild, *Hispania Antiqua*, Mainz, 1978, p. 49a.

7. St George

Probably Constantinople
Late 11th or early 12th century
Silver-gilt repoussé
17.1 × 13.7 cm
Illustrated in colour on the front cover with colour details on page 15

This gilded silver icon-plaque illustrated on the cover consists of a central panel (9.7 × 6.5 cm) and an outer frame (17.1 × 13.7 cm). The central panel bears a full-length, repoussé portrait of the warrior St George. He holds a spear in his raised right hand while his left hand steadies the shield that rests on the ground. He stands on a small platform. An inscription in Greek, ' ΑΓΙΟΣ ΓΕΩΡΓΙ(Ο)Σ ', runs vertically down each side of the figure. On the shield is an inscription or, more accurately, a design, in pseudo-Cufic.

The frame surrounding the central panel provides a narrow border decorated with eight repoussé medallions, each one framed by cogged-rope moulding. Above, in the centre, is the *Hetimasia* (the throne symbolising the Second Coming of Christ) and, to the left and right respectively, the Archangels Michael and Gabriel. On each side are St Theodore (left) and St Procopius (right) while below, in the centre, is St Panteleimon with St Cosmas to the left and St Damian on the right. All these saints are presented as full-face images. The outer edge of the frame is bordered by cogged-rope moulding while the inner border has a similar moulding running along a line of repeated shells. All the inscriptions in the medallions are in Greek. The spaces between the medallions are filled with ornamentation derived from sprouting leaf patterns consisting of either four or six palmette groups.

The condition of the icon is generally good. The gilding is rubbed in some places and there are some slight dents in the borders of the frame. There is a small loss, which cannot be seen from the front, where the silver folds back on its wooden support.

Iconography

The image of St George as a warrior was a type widely employed in the art of the Christian world from the tenth century. In earlier times he was depicted more often as a martyr. But after the tenth century the Byzantines, chronically engaged in protracted wars with the Arabs and with various Turcic tribes such as the Seljuks, preferred the warrior image of which there are several well-known variants: 1. the present example where he stands steadying his shield with his left hand and holding his lance in the right; 2. he is seated on a throne with a sword in his hands; 3. he is mounted on a charger; 4. he is mounted and spears the dragon or, more rarely, the emperor Diocletian.

The cult of St George was widely practised in southern Italy, in Russia, in western Europe, in Armenia and in Georgia. But it was in Byzantium that the greatest veneration was accorded to him. The emperor Constantine the Great had founded the renowned Monastery of St George in the Mangani district of Constantinople and successive emperors who were military leaders adopted St George as their patron.

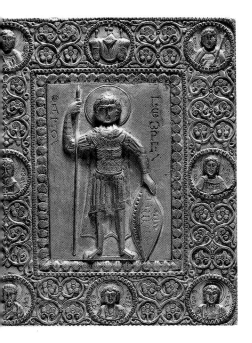

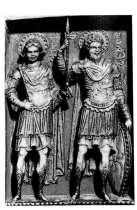

Fig.5

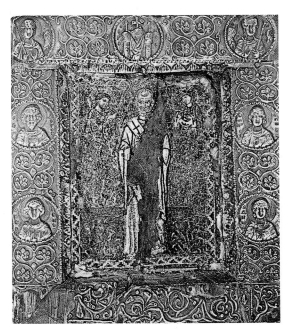

Fig.6

The iconographic type of St George that we see in the Temple Gallery example is the most widely employed. Here St George wears a narrow tunic with tight sleeves, scale armour, cloak, tight knee-length skirt decorated with a lively scroll border and short boots. Such was the military dress and equipment for light cavalry in the Byzantine army.[1]

The same type of armour can be seen in the portrayal of St George on the twelfth-century silver Byzantine bowl from Beriozovo and on the medallion with a mounted warrior on the silver bowl from Vilgort.[2] Further, we can see, in these comparisons with our icon, the same tunics and the same short boots. The separate piece of protective armour for the shoulders and upper arms is a detail common both to our St George and the Beriozovo bowl in the Hermitage. Other warrior saints, as well as emperors depicted as military leaders, are represented in similar armour (e.g. St Theodore Stratilates in the *Menologion of Basil II* circa 986;[3] a twelfth-century icon of St Theodore the Tiro and St Demetrius in the Hermitage;[4] the miniature of Basil II in the Marcian Library Psalter in Venice, circa 1019.[5]

In the imagery of Byzantine warrior saints the cloak – an obligatory feature of the armour – is shown to be tied, usually accurately, with a fibula. In Georgian silver repoussé work, on the other hand, the cloak is tied with a knot hanging down over the chest. (An example of the latter can be seen in the twelfth-century St George from Lengeri.[6] See also fig. 8 and the Archangel Gabriel in St Clement's, Ochrid.)

A detail in the canon of the St George imagery observed by Byzantine artists working in silver repoussé is the treatment of the spearhead. This feature differs in a specific way from those done in Armenia and Georgia where the spearhead in eleventh- and twelfth-century repoussé examples has a three-cornered shape with broader edges.[7] In Byzantine repoussé metalwork, on the other hand, the spearhead consists of an elongated, slightly bulging cone attached to the shaft with a ball or bush. Eleventh-

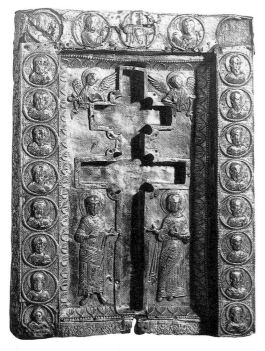

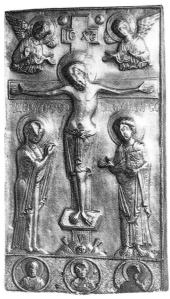

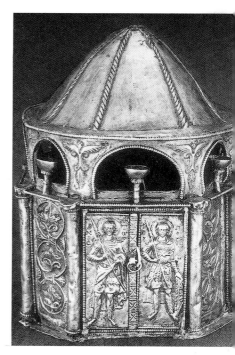

Fig.7 Fig.7 cover Fig.8

century spearheads of this kind from Byzantium can be seen in the ivory triptych of the Forty Martyrs in the Hermitage (fig. 5), on the Reliquary of St Demetrius in the Kremlin Museums (fig. 8) and on a schist icon of St George and St Demetrius in the Hermitage,[8] and in numerous miniatures in Byzantine manuscripts from the tenth to the twelfth centuries.[9]

One further characteristically Byzantine feature is the row of dots on the shield which imitate the nail-heads used for iron bindings. Thus all St George's armour in the Temple Gallery's silver repoussé icon is typically that of Byzantine light cavalry warriors whose equipment had reached its military and aesthetic perfection under the emperor Manuel Comnene. It can be said that the imagery of St George on this icon corresponds in every way to the iconographic types of warrior saints which are found in Byzantium throughout the eleventh century.

There are many analogies for this type of St George in Byzantine art of the eleventh and twelfth centuries. Among them one can cite an eleventh-century steatite icon in Vatopedi,[10] the well-known book cover of the same date depicting the Archangel Michael in the Treasury of St Mark's in Venice (fig. 9),[11] a figure in the twelfth-century mosaics at Cefalu[12] and a twelfth-century icon in the Hermitage of St George, St Theodore the Tiro and St Demetrius.[13] The same St George type is also widely represented in the Caucasus as can be seen among the silver repoussé icons from Dzumati, Khouri and Lengeri.[14, 15]

Here, as elsewhere according to the Byzantine canon, St George is depicted as a young man with a regular oval face, straight nose, thin delicate eyebrows and a piercing look. He is distinguished from other warrior saints by his hair which, as in our example, is thick and curly and arranged in symmetrical rows of curls covering all of

his head including the ears. The type reaches its classical maturity in Byzantium in the twelfth century.

At this period St George was no less popular in Georgia than in the Byzantine world. The Georgians had many workshops specialising in silver repoussé art. However, in depicting St George, Caucasian artists differed from their Byzantine contemporaries in several ways. Faces tended to be longer and narrower and the treatment of the hair was different. More importantly, the repoussé work was done in much lower relief. Further, Georgian artists introduced a sword into the composition, a feature not found in Byzantine icons. V. Lazarev, who studied different iconographic types of St George in the arts of Byzantium, Russia, Palestine, Syria and Asia Minor noted that the Greek masters did not stress the heroic features of the saint.[16] This is why the 'peaceful' type of St George was more widely used in Byzantium, whereas in Armenia, Georgia and Russia the popular type was St George and the Dragon. This may also be the explanation for the absence of a sword in the Temple Gallery icon. In Byzantine art, where St George is depicted with a sword, it is behind his body or hanging by his side.

A highly characteristic element of Byzantine decorative art was the portrayal of saints in medallions. This form was copied from techniques developed by artists working in cloisonné enamel.[17] The frame of the Temple Gallery's repoussé icon, with its seven portrayals of archangels and saints, is iconographically close to this tradition. It appears that the interest of Byzantine craftsmen in silver icon frames increased in the eleventh century. One well-known example from this period is the frame of the icon of St Nicholas in the Monastery of St John on Patmos (fig. 6; see also figs. 7 and 10).

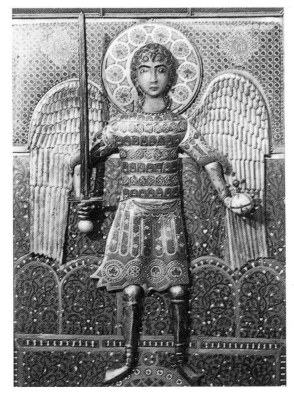

Fig.9

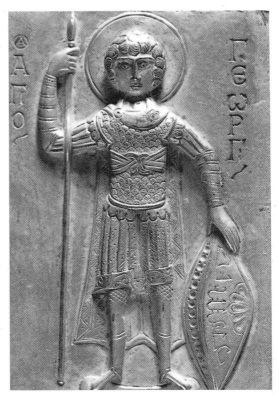

Cat.7

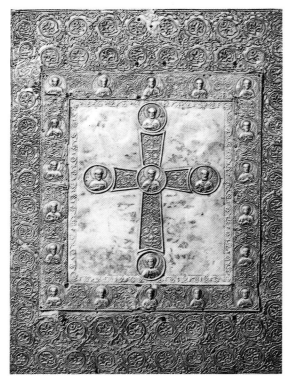

Fig.10

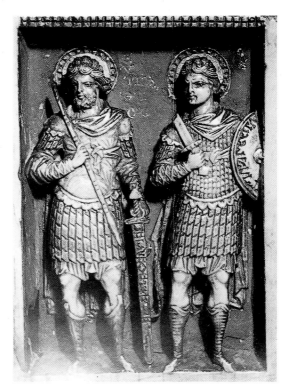

Fig.11

Here, just as in the frame of our St George, a series of small medallions stands out from a background of floral ornamentation that is typical for the eleventh and twelfth centuries. The full-face portrayals in the medallions, few examples of which exist, show the close relationship between the frames of both icons. The iconographic similarities are apparent when we compare the saints on the frame of our icon with those cited above.

All five saints in the frame of the Temple Gallery's icon are popular in Byzantine art. The placing of SS Cosmas and Damian either side of St Panteleimon on the lower border is an arrangement that it shares with the Hermitage stauroteque (fig. 4). Similar portrayals can be seen in Russian and Georgian art.

Palaeography

The Greek inscriptions on the St George, both in the middle panel and on the medallions in the frame, are analogous to a number of Byzantine relics some of which are attributed, while others are precisely dated, to the eleventh and twelfth centuries.

The characteristic features of the palaeography on our repoussé icon are both the general style of the inscriptions as well as the manner of forming the separate letters. The presence of horizontal lines above the letters and the cross bar placed rather low on the letter A, are typical of eleventh-century inscriptions. Such lettering can be seen on the Reliquary of St Demetrius made for the emperor Constantine X (1059–67) (fig. 8). We can find further palaeographic analogies, dated by A. Bank to the eleventh century,[18] when we compare the inscriptions on the middle panel of our icon with

those on the Halberschtadt paten of the eleventh century.[19] The lettering on the middle panel of the St George icon – especially the letters A and P – reminds us of the inscription on the bronze door in San Paolo Fuori Le Mura in Rome. This door was made in Constantinople in 1070 on the order of the Italian nobleman Pantaleone.[20]

The style of the inscriptions on the middle panel of our St George differs from those on the medallions. Since the icon consists of two separate parts, it is likely that the frame was executed by a different craftsman. Nevertheless, the palaeography here can also be safely dated to the eleventh or twelfth century. The closest analogies are the inscriptions on the Hermitage staurotheque (fig. 7) and on the frame of the mosaic St Nicholas from Patmos (fig. 6) and also in the inscriptions on the Halberschtadt paten. The inscription 'ΓΕѠΡΓΙ(Ο)Σ' on the central panel of our St George is analogous to the inscription on a tenth-century ivory triptych in the Louvre.[21]

We can say, from what we have seen so far, that the St George icon is portrayed according to strict iconographical conventions of Byzantine art. The figure of St George himself, the frame and its ornamentation, and the palaeographical details all constitute a traditional image. But there is one unusual and interesting feature which, while also found in Byzantine art of the eleventh and twelfth centuries, cannot be considered traditional. This is the ornamentation on the shield whose plain surface is filled with an 'inscription' that resembles Arabic. It cannot be read or translated and is in fact an imitation of Arabic script or 'pseudo-Cufic' as it is known.[22]

The tradition of combining both Greek and Arabic inscriptions goes back as far as the fourth and fifth centuries. Thus we find Cufic inscriptions on a beaten metal Greek bracelet of that date in the collection of the Walters Art Gallery.[23] There are also many examples of Cufic script being used purely as ornament or decoration. Both in Byzantium and in Europe we find mediaeval craftsmen using Cufic letters without knowing their meaning or even the principles of how they were formed but who merely wished to employ the shapes for decorative purposes. The reason for this can be explained partly by the strong influences reaching the Christian world in the eleventh and twelfth centuries from Arabic culture. It is also partly because Cufic script lent itself so easily to transformation into ornament. Some pseudo-Cufic inscriptions may be cited such as those on a twelfth-century hammered brass tray in the Hermitage,[24] on the well-known ivory triptych of the same date also in the Hermitage (fig. 5), among the mosaics in the Cappella Palatina in Palermo, and in the decorations of Hosias Lukas in Greece.[25] In all cases these imitation scripts are more or less unreadable.

A specialist in Arabic script, studying the inscription on our St George, notes that the script on the shield has been made 'by someone unfamiliar with Arabic and merely copied from Arabic inscriptions' (see Appendix on p. 50). At the same time she has assumed that this 'lettering' was possibly an attempt to copy an actual script probably saying 'Glory is for God'. Her commentary further confirms the 'pseudo' i.e. purely ornamental character of the inscription on St George's shield.

Style

A comparison of the St George figure in the Temple Gallery icon with other examples of plastic representations in Byzantine metalwork in the eleventh and twelfth centuries

shows stylistic proximity. The figure of St George was done in high relief which reveals an important clue to its Byzantine origin in the way the head stands out more prominently from the surface plane than the rest of the body. Here the artist is observing a convention that harks back to antiquity. In addition, he has used the mathematical Byzantine canon of proportion; thus the head, which appears to be large in relation to the body, is in the traditional ratio of 1:6.5. The figures in Georgian silver repoussé icons are usually longer, following the ratio of 1:7.5.[26] At no time does the artist lose the sense of plasticity in the saint's body, even where it is clothed in armour.

The work is gentle and highly refined. The eyes are deep-set, the eyelids are rendered as thin, even lines, the eyeballs shown in the round and the pupils are incised round dots giving the face a compelling look. The treatment of the face is very like that of the face of the Archangel Michael in Venice dated to the second half of the eleventh century. Now preserved in the Treasury of St Mark's, the Constantinopolitan origin of this famous enamel is universally recognised (fig. 9).

All the features of St George that we can observe: the individualisation of the image, the high relief, the rhythms of the drapery and the clothing under which we feel the physical presence of a body, the position of the feet with the toes extended over the edge of the platform – all these details bring our icon firmly into the period of the late eleventh or early twelfth century.[27]

The use of twisted-rope mouldings, which form the frames around the medallions, is a stylistic detail that further supports the attributed date and location. The mouldings are repeated twice as a part of the frame itself. This decorative device is found on other products of Byzantine plastic arts in metal, for example, the paten from the Treasury at St Mark's, the frame of the mosaic icon of St Nicholas at Patmos (fig. 6), and the Maastricht Cross dated to circa 1032,[28] and is further developed in the ornamentation of the thirteenth-century cross in Dumbarton Oaks.[29]

The heads of the saints in the medallions on the frame, while not losing their individuality are, however, treated more schematically than that of St George, as can be seen, for example, in the treatment of the hair. Comparison with the St Mark's Treasury Book Cover shows that the twenty-two saints represented on its borders are treated in the same style and manner (fig. 10).

The artistic inequality between the central panel and the frame suggests the work of two different craftsmen, though it is likely that both men worked in the same workshop. Evidence supporting this hypothesis is obtained from the microanalysis of the silver on the two parts of the icon and a third sample taken from the edge of the frame. This was undertaken by Dr P. Northover of the Department of Metallurgy and Science Materials at Oxford University who states that the 'three compositions are statistically indistinguishable'. Further, he says that it is 'quite likely that all three samples, and thus the two parts of the icon, come from the same sheet of silver' (see Appendix on page 48).

The schematic treatment of the pictures in the medallions on the frame, compared with the pictorial treatment of the main figure, suggests that the frame has less significance than the central image to which it is accessory. The comparatively low relief of the beaten metalwork on the figures in the frame may be similarly explained.

Such stylistic discontinuity is an artistic device that can be traced back to late classical reliefs which Byzantine art preserved up until the tenth century. In this sense the St George icon can be thought of as a variant gravitating towards the classical sources of Byzantine style, towards the ideals of the so-called 'Macedonian Renaissance' of the tenth century. However, the iconographical and palaeographical features already discussed mean that this icon cannot be placed in the earlier period. The floral ornamentation of the frame, which is not freely treated and yet which is not static, and the characteristic style and manner of the inscriptions, rather firmly suggest a date in the late eleventh or early twelfth century. Tendencies which are unquestionably Byzantine become apparent when we consider the techniques employed by the craftsmen. Sophisticated hammering methods allowed the artists to stress every detail of the saint's armour and also the frame ornamentation. These stylistic and technical qualities, taken together with evidence of the highest standards of craftsmanship, would put this work at the centre of Byzantine artistic production, namely Constantinople. Scholars researching in the arts of Byzantium note that it is precisely the Constantinopolitan works that come closest to oriental patterns.[30] The pseudo-Cufic inscriptions are an indication of this.

Frames consisting of a double row of flower ornamentation are widespread in Byzantine miniature decoration from the tenth to the twelfth centuries.[31] The same design was used on the eleventh-century silver stauroteque in the Hermitage (fig. 7) and for a similar stauroteque from the Treasury of San Giovanni in Rome[32] and also a stauroteque of the twelfth century in Saxony.[33] The same ornamentation covers the surface of the crosses on the Hermitage and Marienschtern stauroteques. All these stauroteques are stylistically analogous to the Limburg stauroteque, which is dated to the tenth century, and there is thus no doubt that collectively they illustrate the development of the floral decorative style.

Conclusion

Iconographic, palaeographic and stylistic analyses of the repoussé icon of St George unambiguously show that it belongs within the circle of Byzantine arts of the 'high style'. The outstandingly high level of craftsmanship, particularly in the hammering technique, indicates a date in the period regarded as the blossoming of the Byzantine applied arts – the late eleventh century and early twelfth century – and very probably a Constantinopolitan workshop.

N. K.

Notes

1. Philip Sherrard, *Byzantium*, Amsterdam, 1986, p. 84.

2. V. P. Darkevitch, *Svetsoe Iskusstvo Vizanti*, Moscow, 1975, p. 80.

3. Ibid. p. 214.

4. V. N. Lazarev, *Istoriya Vizantiiskoy Zhivopisi*, 1948.

5. Darkevitch, op. cit., p. 246.

6. A. A. Kuznetsov, *Verkhnya Svaneti*, Moscow, 1974, p. 79.

7. Darkevitch, op. cit., p. 130. See also G. N. Chubinashvili, *Gruzinskoye Chekannoe Iskusstvo*, Tbilisi, 1957.

8. Exhibition catalogue, *Iskusstvo Vizantii*, Moscow, 1977, vol. 2, p. 113.

9. V. N. Lazarev, op. cit., vol. 2, Moscow, 1948.

10. N. P. Kondakov, *Pamyatniki Khristianskogo Iskusstva na Afone*, St Petersburg, 1902, p. 81.

11. O. M. Dalton, *Byzantine Art and Archaeology*, Oxford, 1911, fig. 306.

12. O. Demus, *The Mosaics of Norman Sicily*, London, 1949, ill. 7a.

13. V. N. Lazarev, op. cit., ill. 204.

14. N. P. Kondakov, *Opis Pamyatnikov Drevnosti v Khramakh i Monastyrakh Gruzii*, St Petersburg, 1890, pp. 106–8.

15. Sh. Amiranashvili, *Istoriya Gruzinskogo Iskusstva*, Moscow, 1950.

16. V. N. Lazarev, 'Novuy Pamyatnik Stankovoy Zhivopisi 12 Veka i Obraz Georgiya-Voina v Vizantiskom i Drevnerusskom Iskusstve', *Vizantiisky Vremennik*, 6, Moscow, 1953, p. 192.

17. A. Bank, *Prikladnoye Iskusstvo Vizantii 9–12 Vekov*, Moscow, 1978, fig. 31.

18. Ibid., p. 35.

19. Ibid., fig. 25.

20. Ibid., fig. 59.

21. D. Talbot Rice, *The Art of Byzantium*, London, 1959, pl. 101.

22. G.C. Miles, 'Painted Pseudo-Cufic Ornamentation in Byzantine Churches in Greece in *Actes du 14e Congrès International des Etudes Byzantines*, vol. 3, Bucharest, 1976.

23. R. Ettinghausen, *Islamic Art in the Metropolitan Museum of Art*, 1972, p. 181.

24. E. V. Kilchevskay, N. N. Negmatov, 'Shedevrui Torevtiki Ustrashany', *PKNO*, 1978, Leningrad, 1979, pp. 458–70.

25. G.C. Miles, 'Byzantium and the Arabs: Relations in Crete and the Aegean Area', in *Dumbarton Oaks Papers*, 18, 1964, pls. 54–5.

26. Sh. Amiranashvili, *Beka Opizari*, Tbilisi, 1956.

27. A. Bank, op. cit., fig. 78. See also V. A. Mishakova 'Pamyatnik Vizantskoy Reznoi Kosti Iz Gos Istorichekogo Museya' in *Musei*, N4, Moscow, 1983, pp. 94 and 96.

28. A. Bank, op. cit., p. 31.

29. M. C. Ross, *Catalogue of the Byzantine and Early Mediaeval Antiquities in the Dumbarton Oaks Collection*, vols. 1–2, Washington, 1962–5.

30. A. Bank, op. cit., p. 150.

31. P. Buberl, H. Gerstinger, *Die Byzantinischen Handschriften* Bd 2, Leipzig, 1938, tabs. 64,3, 66,4. See also, K. Weitzmann, *Die Byzantinische Buchmalerie Des 9 und 10 Jarhunderts*, Berlin, 1935, tabs. 19, 104; tabs. 24, 145.

32. A. Bank, op. cit., fig. 12.

33. Ibid., fig. 13.

APPENDIX I

Microanalysis of an eleventh- to twelfth-century icon from Georgia carried out in the department of Metallurgy and Science Materials in the University of Oxford

Three samples were taken from an eleventh- to twelfth-century icon from Georgia, submitted by the Temple Gallery. Two samples were drilled, using a 0.4mm bit in a hand-held modelmaker's electric drill. These were taken from the lower left corner of the central portrait plaque (sample no. RLAHA 37) and from the area of the lower left portrait roundel of the frame (RLAHA 38). A sample was also cut from part of the flange of the frame using a jeweller's piercing saw with 32 teeth/cm. Parts of the flange appeared to have broken away and been soldered in place so this sample was taken to confirm that the flange was of the same metal as the rest of the frame. A solid sample could also be used to give some idea as to the state and structure of the metal, although a full metallographic report cannot be prepared at this stage because of a lack of facilities for cyanide etching. The samples were hot-mounted in a copper-filled acrylic resin, ground and polished, the final polish being with 1μm diamond paste.

The analyses were carried out using the CAMEBAX automated electron probe microanalyser in the Department of Materials, University of Oxford. Each sample was

TABLE 1		37 Portrait	38 Frame	39 Flange
Iron	Fe	0.01	.	.
Cobalt	Co	tr	0.01	0.01
Nickel	Ni	tr	0.01	0.03
Copper	Cu	3.00	2.58	2.51
Zinc	Zn	0.01	0.01	0.01
Arsenic	As	.	.	.
Antimony	Sb	tr	tr	0.01
Tin	Sn	.	.	.
Silver	Ag	95.06	95.76	95.93
Bismuth	Bi	0.02	.	0.01
Lead	Pb	0.34	0.31	0.27
Gold	Au	1.31	1.30	1.21
Sulphur	S	tr	0.01	.

TABLE II		1	2
Iron	Fe	0.02	0.12
Cobalt	Co	.	.
Nickel	Ni	.	.
Copper	Cu	0.43	1.06
Zinc	Zn	.	.
Arsenic	As	.	.
Anitmony	Sb	0.04	0.02
Tin	Sn	.	.
Silver	Ag	14.48	21.83
Bismuth	Bi	.	.
Lead	Pb	.	.
Gold	Au	85.02	76.78
Sulphur	S	.	0.14

analysed at three points, the analysed area being 25µm square. The means of the three analyses for each sample are set out below, the limits of detection being 100–200ppm for all elements except gold and arsenic where it is 400–500ppm. See Table I.

These three compositions are statistically indistinguishable: the experimental error for each silver analysis cannot be less than 1 per cent and the scatter of the results lies within this. Even the three values for the most variable element, copper, lie practically within the experimental error for that element, but it is likely also that copper has the most variable distribution within each sample. It is therefore quite likely that all three samples, and thus the two parts of the icon, come from the same sheet of silver. In the absence of easily available comparative data it is unwise to express a greater degree of certainty at this stage.

The lead contents are quite typical for ancient silver but the high gold content is noteworthy and would be a key element to study should similar pieces become available for analysis.

Examining the metallographic sample in the polished state showed that the metal was generally in good condition. There was a small amount of intergranular corrosion at the surface with a narrow band of slight corrosion attack parallel with the surface and just below it. This corrosion pattern is consistent with the probable history of the piece. The polished surface showed a scatter of small non-metallic inclusions. The majority were of copper and lead oxides, to be expected from silver that has been refined by cupellation. (Other inclusions appeared to be of silica but may have derived from the papers used to grind the sample before polishing.)

The sample drilled from the frame (RLAHA 38) retained traces of the gilding of the front of the icon. These traces were sufficiently large to permit their analysis, also with a $25\mu m$ square analysed area. The results from two saques are shown in Table II::

The sections of gilding analysed were very thin so interpretation may be complicated by the beam of the microprobe penetrating to the silver beneath. A qualitative search was made for mercury but no mercury peak was detected in the energy dispersive spectrum. Mercury gilding typically leaves 8–15 per cent mercury in the gilding layer which is easily identified. Also, the characteristic porous structure of mercury gilding was absent. An examination of the gold-silver interface using a back-scattered electron image in atomic number contrast suggested the presence of a definite diffusion zone. This in turn suggests that leaf gilding was applied to the icon which was then heated to diffusion-bond the gold to the surface. It is possible that the different silver contents in the analyses above simply represent analyses taken at different depths in this diffusion-bonded layer.

P.N.

APPENDIX II

Dear Sir,

The inscription on the piece you sent me was done by someone unfamiliar with Arabic, and merely copied from Arabic inscriptions. I can only give a possible reading which is by no means certain.

The copied inscription on the photograph could originally have been:

'Glory is for God . . .' عز لله . . .

Manijeh Bayani

FRESCO

8. Head of a Saint
Said to have come from Syria
10th century
Fresco
31 × 26 cm
Illustrated in colour on page 16

The fresco is the companion of a similar head, though of an older man, on loan to the Metropolitan Museum in New York from the Ortiz collection (fig. 12).

Both heads are close to the iconographic canon and also the stylistic features of Byzantine frescoes and mosaics of the tenth and early eleventh centuries. The absence of the saints' garments and of inscriptions partly inhibits iconographic analysis and narrows the possibility of making a full attribution for these Byzantine portraits. None the less, close study of the painter's graphic manner, particularly in rendering the facial features, allows us to draw a number of firm conclusions.

There is no doubt that we see here painting that has roots in two artistic traditions. The painter follows the artistic manner of Graeco-Roman antiquity while, at the same time, his work reflects the influence of monumental oriental art. There is no firm evidence that both heads are either from the hand of one painter or even from the same fresco (although that is likely to be the case); but the extremely high artistic level and the masterly technique of portraiture affirm that both paintings belong to the same period of the development of Byzantine art.

The grandeur and monumentality of the faces of both saints relates them to classical Greek art, as do the taut lines of their features and the volumetric modelling of the faces. On the other hand an oriental influence is signified by the deep inner

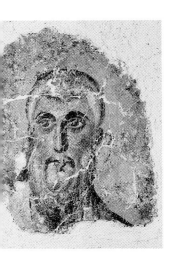

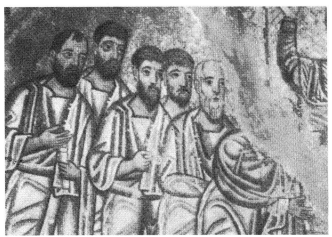

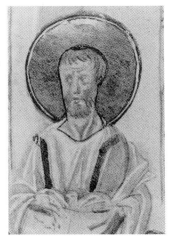

12 **Fig.13** **Fig.14**

expressiveness and also by the ethnic type suggested by the faces – particularly the way in which the eyes are modelled.

It is generally considered that the pinnacle of the development of Byzantine art was the period in the tenth century known as the Macedonian Renaissance. Both these heads are fully integral to the art of this epoque.

Among the few monumental paintings from this period that have survived we can cite the early-eleventh-century mosaic of the Doubting of Thomas in Hosias Lukas in Greece (fig. 13). Here both the style and the iconography of the apostles is close to the fresco in the Temple Gallery and its companion in the Metropolitan Museum. The similarity is especially noticeable in the form of the eyes and eyebrows and the modelling of the heads. There is also an analogy in the way the head of St Mark is portrayed in a tenth-century MS preserved on Mount Athos (fig. 14). Further useful comparisons are provided by three Byzantine illuminated manuscripts: a figure of St Paul in Athens,[1] a Head of a Prophet in Turin[2] and an image of a saint in the Vatican.[3]

It is known that in the tenth and eleventh centuries many artists and craftsmen from the eastern parts of the Byzantine Empire received their training in Constantinople. While achieving the high standards of the metropolitan workshops their work nevertheless retained some features of oriental character. The aesthetic principles of the Antique always lie close to oriental elements in the arts of the eastern parts of the Empire. The intermingling of these two strands, such as we find in the Temple Gallery and Metropolitan Museum frescoes, indicates an origin in Syria. At the same time there is no doubt that both examples represent the high art of Byzantium in the tenth or early eleventh centuries, the period of its greatest splendour.

N. K.

Provenance
George Ortiz Collection
The Timken Art Gallery, San Diego

Exhibited
The Temple Gallery, 1977
Rochester University Art Gallery, New York

Notes
1. Athens, National Bibl., Cod. 210.

2. Turin University Library, Cod. B.1.

3. Vatican Menologion, Cod. gr. 1613.

MANUSCRIPT

9. The Entry into Jerusalem

Syria
12th century
Parchment
434 × 294 mm
Illustrated in colour on page 17

The single sheet (fragment) with a miniature from a Syriac parchment codex of the New Testament was found in the Tur-Abdin area, south-east Turkey. The parchment is cut with an irregular edge and with a flaw. The calligraphic Estrangela script in gold (red contour) and black-brown is in two columns of twenty-four lines. The finish is painted with gold; the main colours are shades of red, blue, green and yellow with the insides of the letters drawn in black with white spaces.

This single sheet from a late twelfth-century Syriac New Testament manuscript of large format can be considered an outstanding example of manuscript illustration under Byzantine influence. Syriac manuscripts are nowadays extremely rare in the market and are usually fragmentary. This example is from the Paris collection of Jean Pozzi which was dispersed in 1971. The page was listed in the inventory of Jules Leroy.[1]

It is a jewel among the painted manuscripts of the Orient. The miniature illustration (215 × 215 mm), surrounded by entwined decorations spreading out from the margin like a convolvulus plant, depicts the entry of Christ into Jerusalem and is of very high artistic quality and iconographic importance. Christ rides on a colt into Jerusalem and this is the beginning his last stay in the city. The Christian churches celebrate this event, recorded by the four evangelists (Matthew 21, 1–11; Mark 11, 1–10; Luke 19, 29–40; John 12, 12–19) with few variations in their accounts, as Palm Sunday, the Sunday before Easter.

In early Christian art the Entry into Jerusalem was already interpreted and presented as the triumphal procession of Christ while on earth. In the course of the centuries this Hellenistic imagery has hardly altered. There is also an historical and narrative motif: Christ rides side-saddle like the Arabs and he is bearded. He holds a scroll in his left hand and he is received at the city gate, behind which domed houses can be seen. Other conventional details, traditional for this iconography, are included: the head of the colt is lowered towards the ground, a child appears among those in front of the city gate, and Zacchaeus, the chief tax collector who is small in stature, has climbed up a tree the better to see Christ. This latter detail, as Luke 19, 1ff. records, takes place in Jericho but is often included in the Entry into Jerusalem. In our miniature, Zacchaeus is perched in a mulberry tree situated between the city walls and the Mount of Olives, which stands out against the gold leaf background as a landscape motif in grey-blue and pink.

Before the gates stand the citizens of Jerusalem, receiving Christ. A man, apparently one of the disciples, holds a palm branch and a woman stands next to him. Closely grouped around Christ are the eleven other disciples. St John the Evangelist is distinguished by the Bible in his hand. Christ himself wears a blue tunic and a dark brown cloak and points with his right hand towards the gates, which appear to be still closed. The city wall, crowned with battlements, glows in pink. Some of the inscriptions in red Estrangela script are to be read as the text accompanying the picture.

Although the illustration is fragmentary it is still preserved with its main narrative elements intact. Even the fact that a few small fragments are missing does not prevent us from appreciating the quality, especially that of the drawing of the faces. The features of the handwritten text, in outstanding Estrangela calligraphy, including those of its layout – pencil lines separating the columns and marking the lines, and holes on the design around the edges shaped like the eye of a needle – add to the attractiveness of the page. The vowels for some words are indicated by fine dots, and accents which split up the text are marked in carefully rounded points above, on or under the line.

On the back of the page, which was in fact the *recto*, a green strip, drawn in, separates the two sections.

Text

Above, the manuscript, written in brown ink, gives the verses for the Entry into Jerusalem from Matthew 20, 27ff. Below, in gold lettering, the equivalent verses from Luke 19, 28–36.

Condition

The page has been cut slightly irregularly along the white gutter margin. The flaw follows a curved diagonal which runs from the top third of the margin down to the foot of the page. There are smudges in the colours and finger marks in some places. The page has been folded.

<div align="right">J. A.</div>

Note

1. *Manuscrits Syriaques à peinture, Conservés dans les Bibliothèques d'Europe et d'Orient*, Paris, 1964, p. 416, fig. 53.2.

JEWELLERY

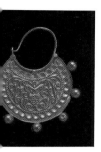

10. Lunate Earring

Early Byzantine
7th century
Gold
6.3 × 5.4 cm
Illustrated in colour on page 18

The earring is composed of three parts: a loop made of strong wire, a semicircular main section attached to the lower part of the loop and the additional border section consisting of seven hollow globules attached to the lower rim. Small gold discs at the junction between the loop and the lunate section reinforce the ornament.

The crescent-shaped section of the earring is decorated in repoussé and consists of a central design of highly stylised arabesques within, with a beaded border and an ovolo pattern. The arabesques are formed of symmetrical vegetal scrolls that grow from a central vase with S-shaped handles. Both the circular body and the neck of the vase are embellished with a foliate design.

The earring is a particularly fine example of a popular type of early Byzantine jewellery. The compositional scheme – a perfect solution for fitting the abstracted scrollwork into the crescent shape – and the deft execution of all the details display the art of the Byzantine goldsmith at its best. The earliest examples of this type of earring date to the later sixth century.[1] The repoussé decoration on our earring, however, is more characteristic of the seventh century. A similar repoussé earring, also decorated with a beaded border and ovolo pattern (encircling, however, two confronting lions), was discovered in Beit Shean during excavations in 1986.[2] It was found with a number of coins which suggest a mid-eighth-century date. This discovery proves the continuity of the type even after the Arabic invasion and demonstrates the connection between early Byzantine and early Islamic art. A similar vase with scrollwork design appears on a repoussé-decorated earring of unknown provenance in the princely collection of Czartoryski.[3]

Most early Byzantine crescent-shaped earrings are decorated in openwork and feature the so-called peacock design, two birds confronting each other with a plant or a vase between them.[4] This feature is generally considered to be a symbol of paradise where the soul (symbolised by a bird) is regenerated at the source of life. Another symbol of paradise is the plant emerging from a vase as on our earring. This motif is related to the Tree of Life as described in Genesis 2, 8–9. The motif was not, however, restricted to Christian art. It also became a leitmotif in decorative Islamic art.

B. D.-L.

Notes

1. See A. Bank, *Byzantine Art in the Collections of Soviet Museums*, Leningrad, 1977, pl. 97.

2. See Na'ama Brosh, *Islamic Jewellery*, Israel Museum, Jerusalem, 1987, p. 8, fig. 3 and p. 68.

3. See M. Ruxer/J. Kubczak, 'Bijouterie Antique de l'Ancienne Collection Czartoryski à Cracovie', *Archeologia*, XXV, 1974, p. 81, no. 42, fig. 29.

4. Cf. K. Weitzmann (ed.), *The Age of Spirituality*, New York, 1977–8, p. 315, no. 290; A. Yeroulanou, *Journal of the Walters Art Gallery*, no. 16, 1988, p. 5.

11. Byzantine Earring

10–11th century
Gold and enamel
4.8 cm
Illustrated in colour on page 18

The earring is formed from two convex sheets of gold which are ring-shaped except for a semicircular section cut out at the top which gives it an almost lunate shape. The ear loop is fastened to it by small hinges. On both sides of the earring the surface is completely covered with ornamental designs in polychrome cloisonné enamel. On the front, an ornamental border with an outer row of square cloisons and an inner row of red triangles and red quatrefoils in off-white roundels is set against a blue background. It encircles an area covered by a regular pattern of tiny red quatrefoils set against an off-white background. In the centre there is a medallion with a plain golden frame held between two enamelled lines, one in red and one in blue. The medallion contains a three-quarter representation of a female head with delicate features and curly black hair set against a luminous background of pale bluish green. The lady represented cannot be identified.

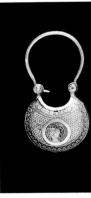

Cat.11

The back of the earring is covered by an intricate foliate design of heart-shaped ornaments and dense scrolls, outlined in gold against the blue and red of the enamelled background. The vivid pattern contrasts with a border consisting of a row of off-white quatrefoils set against a red background between two rows of square cloisons with blue inlays.

Typologically the earring fits into the range of Byzantine ear pendants of the tenth to the eleventh century AD. Its shape and decoration closely relate it to an enamelled bronze earring found in Corinth,[1] while the superb artistic quality of the design and the deft craftsmanship associate it with a few particularly fine examples of secular enamel from the same period. The piece can be attributed to the same workshop as a drop-shaped ornament, a button or pendant of unknown provenance, now in the Dumbarton Oaks Collection.[2] A finger ring from the so-called treasure of the empress Gisela – a group of mainly Ottonian jewellery, found in 1880 in Mainz, Germany – probably also originated from this workshop.[3] A similar foliate pattern in multicoloured enamel occurs on the fragment of a crescent-shaped ornament in the Cleveland Museum of Art.[4] The head in the medallion recalls figural representations on the eleventh-century crown of Constantine Monomachos.[5] The date suggested by these

comparisons is confirmed by several examples of religious enamels using similar ornamental patterns; for example, the staurotheque in Limberg,[6] the cruciform staurotheque in the Vyssi Brod (Hohenfuhrt) monastery[7] and the Khahuli Triptych.[8]

<div align="right">B. D.-L.</div>

Notes

1. See G. R. Davidson, *Corinth XII, The Minor Objects*, 1952, no. 2045, pl. 108.

2. See M. C. Ross, *Catalogue of Byzantine and Early Mediaeval Antiquities in the Dumbarton Oaks Collection, Vol.II: Jewellery, Enamels and Art of the Migration Period*, Washington, 1965, no. 151.

3. See O. Falke, *Der Goldschmuck der Kaiserin Gisela*, no. 14, pl. 1.5a.

4. *Early Christian and Byzantine Art*, Exhibition Catalogue, Walters Art Gallery, 1947, no. 445; also,

W. M. Milliken, 'Byzantine Jewellery and Associated Pieces', *Bulletin of the Cleveland Art Museum*, 7/1, Sept. 1947, p. 147.

5. See K. Wessel, *Die Byzantinische Emailkunst*, 1967, pp. 98–106, no. 32, or the English edition published in the same year.

6. See Wessel, op.cit., pp. 77–8, no. 2b.

7. See J. Deer, *Die Heiliger Krone Ungarns*, 1966.

8. See Georgian State Museum of Fine Arts, *Mediaeval Cloisonné Enamels*, 1984, p. 140, fig. 211.

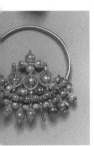

12. Byzantine Pearl Earring

9th–10th century
Gold and pearls
Height: 7.2 cm Weight: 48.8 g
Illustrated in colour on page 18

The earring consists of a crescent-shaped strip of gold forming the lower part of a ring-shaped loop and of a bent wire which slightly tapers towards the open end. Three strands of pearls are arranged along the crescent-shaped part and are kept in position by a wire passing through them and held by loops soldered at regular intervals to the base plate. Larger loops of the same ribbon-like type radiate from the outer edges, again alternating with revolving pearls secured by gold wire. They support projecting pegs mounted with large pearls which are kept in place by hollow pellets. Three circular gold frames with beaded edging are vertically attached to the inner edge, each fitted with a central pearl on wire. A further vertical projection consists of four pearls, elaborately arranged in the shape of a cross. The junction between the lower section and the wire, as well as its open end, are reinforced by small ornaments composed of plain wire rings. The open end is marked by an additional large pearl.

Pearls are easily subject to decay. In the present case, however, out of forty-one pearls thirty-nine are still in place and most of them have kept their original satin lustre. They have been carefully selected and arranged according to size, with the colours varying from a faint pink to various shades of grey.

The earring forms a pair with a matching piece in a private collection.[1] No other direct parallel is known, but the basic concept – a loop with a flat, decorated lower section and an additional ornament placed in vertical position in the lower segment –

and the use of pearls mounted on a plain frame with beaded edging affiliate it to a well-known group of earrings.[2]

A ninth- to tenth-century date for this group is suggested by an example found in a grave in Corinth which also contained a bronze earring of a type that does not appear before AD 800.[3] A tenth-century date is provided by a later pair with an enamelled roundel in the lower segment, showing the bust of the Byzantine emperor, John Tzimisces (AD 969–76).[4]

B. D.-L.

Notes

1. See K. R. Brown in *The Age of Spirituality*, ed. Weitzmann, New York, 1977, no. 307.

2. See O. M. Dalton, *Catalogue of the Early Christian Antiquities in the British Museum*, London, 1901, no. 267, pl. IV; P. Orsi, 'Byzantina Sicilia', *Byzantinische Zeitschrift*, 19, 1910, p. 464; E. Coche de la Ferté, *Collection H. Stathatos III, Les Objets Byzantins et Post-Byzantins*, 1957, pp. 18–22, nos. 4–5, pl. 2; P. Amandry, *Collection H. Stathatos III, Objets Antiques et Byzantins*, 1963, nos. 214–16; F. Naumann, 'Antiker Schmuck', *Vollständiger Katalog der Sammlung und*

Sonderausstellung, Staatliche Kunstammlungen Kassel, 1980, nos. 103–6, pl. 20; T. Ergil, *Kupeler–Earring, The Earring Catalogue of the Istanbul Archaeological Museum*, 1983, nos. 144–8.

3. See G. R. Davidson, *Corinth XII, The Minor Objects*, 1952, no. 2036, pl. 108.

4. See H. Klunk, *Kunst der Spätantike im Mittelmeerraum*, Berlin, 1939, no. 88, p. 17; Klunk, *Eine Gruppe Datierbarer Byzantinischer Ohrringe*, Berliner Berichte 61, 3, 1940, pp. 42–7.

13. Byzantine Finger Ring

9th–10th century
Gold and pearls
Height: 2.4 cm Weight: 12.43 g
Illustrated in colour on page 18

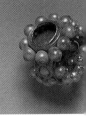

Cat.13

A plain hoop, bordered on each side by a small ridge, frames a row of pearls placed into matching openings and surrounded by beaded circlets. The pearls are pierced and threaded on wire. Short pins fitted with slightly larger pearls and with golden pinheads are attached to both sides of the hoop. The bezel consists of a (now empty) oval box setting surrounded by a tight row of pearls of slightly larger size, mounted in the same way. The pearls are not only in perfect condition, but all of them have obviously been carefully selected according to size and colour.

The stylistic similarities, the lavish use of pearls and the unusually perfect condition relate this ring to the Byzantine pearl earring (catalogue no. 12) with which it is said to have been found. Pearls surrounding a bezel occasionally occur on Byzantine finger rings. Hoops heavily ornamented with pearls of the highest quality – the epitome of luxury – are extremely rare. The only known parallel seems to be a comparatively plain finger ring of unknown provenance in the Dumbarton Oaks Collection, generally considered to be unique.[1]

B. D.-L.

Note

1. See M. C. Ross, *Catalogue of Byzantine and Early Mediaeval Antiquities in the Dumbarton Oaks Collection*, vol. III, Washington, 1965, no. 71.

STEATITE

14. A Double-sided Pendant with Forty Saints

Carved in steatite with a gold and *plique-à-jour* mount
Constantinople or Mount Athos
Late 14th or early 15th century
4.6 × 4.1 cm
Illustrated in colour on page 19

The saints are arranged in four rows of five figures on both the obverse and reverse sides. They are separated by vertical and horizontal walls of approximately 1 mm depth that frame each saint in his own niche which measures 10 × 7.5 mm. These frames are less than 1 mm thick and in the right angles where the corners meet the artist has carved a circular loop. The saints are shown half-length. Each is identified by an inscription giving his name and, in certain cases, his calling. Details of dress, facial type and expression, age, gestures and so on are accurately and individually done. The carving, miraculous enough for its miniature scale, continuously interests us by its inventiveness and originality. It is never mechanical or repetitious.

In the upper row on the obverse side we see martyrs depicted as youths or as men in the prime of life. Reading from left to right are:

1. St Eustathius (patriarch of Antioch, noted for his defence of Orthodoxy against Arianism, d. 338); he is shown as a young man with short beard, wearing a cloak clasped at the right shoulder and holding a cross in his right hand, the left hand covered.
2. St Eustatius (St Eustace, a legendary – though famous – figure whose cult, in the West, is confused with that of St Hubert); a bearded man also in a martyr's cloak holding a cross and his left hand raised.
3. St Procopius (warrior and martyr, d. 303); a young, beardless man holding a cross, his left hand covered.
4. St Artemius (martyr, d. 363); a man with a short beard and wearing a martyr's cloak, holding a cross, his left hand raised.
5. St Menas (Roman soldier, d. 296); similarly dressed, bearded, left hand covered.

In the next row are bishops. These are shown as slightly older men but still in their prime. They are clearly identifiable as bishops by the crosses on their stoles and by the episcopal *maphorion* which they wear. They each hold the gospel in their left hand, though at different angles, and the blessing gestures of their right hand vary.

6. St Peter of Alexandria (martyr, d. 311).
7. St Gregory the Great (Pope of Rome, doctor of the universal church, d. 604).
8. St Gregory (inscription partly damaged, perhaps Naziansus).

9. St Spiridon (Bishop of Tremithus in Cyprus, buried on Corfu, fourth century), 'the shepherd of souls', he wears the characteristic conical shepherd's hat of antiquity.
10. Dionysius the Areopagite (fifth-century Christian-Platonist and the author of highly influential mystical writings; in the Middle Ages he was thought, wrongly, to have been the pupil of St Paul referred to in the Acts of the Apostles).

In the next two rows we see monks of the early Christian period associated with the establishment of monasticism especially in the deserts of Egypt, Syria and Palestine. They are shown as older men with intense expressions associated with their spirituality. They wear the monastic habit. The cowl sometimes covers the head but is more often thrown back; beards are longer and in a variety of styles that give great individuality and character to each saint. Most hold scrolls which they indicate in various gestures.

11. St Antony (of the Theban desert, said to be the 'father of monasticism', d. 356).
12. St Paul of Thebes (also known as Paul the Hermit. He was 'discovered' by St Antony having lived in a cave for ninety years, d. 362.); he has no scroll and raises both hands in a gesture of prayer.
13. St Euthymius (mystic, d. 473); he turns slightly left and holds a sheaf of scrolls.
14. St Savas (St Sabas, influential monk and scholar in Egypt, d. 540).
15. St Arsenius (solitary monk, d. 449).
16. St Theodore the Cenobite (ascetic monk and philanthropist, defender of Orthodoxy against Monophysitism, d. 529 aged 105).
17. St Hilarion (monk and abbot in Palestine, d. 371).
18. St John the Silent (monk and pupil of St Savas, d. 558).
19. St John Climacus (St John of the Ladder, mystic and writer, d. 649).
20. St Ephraim the Syrian (writer, hymnographer and mystic, d. 649).

Turning to the reverse side we find, in the upper row, five ascetics.

21. St Alypius (the Stylite, lived on top of a pillar for sixty-seven years, sixth century); he is shown in the enclosed section on top of his pillar.
22. St Onuphrius (solitary monk, lived naked in the desert, d. 400); we see him naked and with an exceptionally long beard.
23. St Daniel (the Stylite, the most famous after St Simeon whom he inspired, d. 493); he is seen on top of his pillar.
24. St Macarius (the Elder, lived for sixty years in the desert, d. 390); he is wearing animal-skin clothes.
25. St Simeon (the Stylite, the most famous of this genre of asceticism, his monastery still exists, d. 459); he is seen on top of his pillar.

The next row has monks and mystics.

26. St John the Calybite (lived in a hut in Constantinople as a beggar, date unknown).
27. St Alexis the Man of God (Syrian ascetic, tenth century); the legendary material about him (abandoning his wife and family on the eve of his wedding in order to seek holiness, etc.) is identical for both St John the Calybite (no. 26) and St Alexis. The

latter is better known especially in Russian iconography.

28. St John of Damascus (theologian and doctor of the church, defender of icons against iconoclasm, seventh century); he wears the characteristic turban of Damascus.

29. St Cosmas the Hymnographer (also known as 'of Jerusalem' and 'Melodus', a well-known religious poet of the eighth century). He was bishop of Maiuma near Gaza and is shown here as a monk.

30. St Theodore the Studite (the great abbot of the Studion Monastery in Constantinople, defender of icons against iconoclasm, d. 826).

In the third row are depicted saints associated with health and, in the case of St Triphon (no. 35), ecology. The first two are traditionally taken together.

31., 32. SS Cosmas and Damian (the '*anargyroi*', i.e. 'without money', were physicians who gave their services without payment, third century).

33. St Panteleimon (patron saint of doctors, date unknown). All three medical men hold scalpels in their right hand and books or scrolls in their left.

34. St Ermolaos (so far no known references to this saint).

35. St Triphon (martyr, patron of gardeners, protector of plants, especially vines, d. 250); he is shown as a beardless youth holding a flower in his right hand.

In the last row we see:

36. St Stephen the Younger (martyr, defender of icons against iconoclasm, d. 765); he holds an icon in his covered left hand which measures 3 × 2 mm and on which, quite distinctly, is an image of Christ.

37. St Andrew of Crete (monk, martyr and defender of icons against iconoclasm, d. 766).

38. St Athanasius (possibly Athanasius of Alexandria); he is shown as a monk holding an open scroll.

39. St (?) Euphrosynus (the first letters are obscure); he is depicted as a monk and holding a cross of unusual form in his right hand.

40. St Akakius the Obedient (very little known but he appears in frescoes at Chilandar on Mount Athos).

R. C. C. T.

STONE SCULPTURE

15. Round Altar Table Top with Christogram

Early Byzantine
4th–6th century
Marble
Diameter: 124.5 cm
Illustrated in colour on page 20

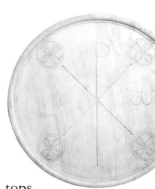

Cat.15

This rare piece belongs to a quite small group of early Byzantine round table tops. These have been numbered in the literature at no more than fifteen so far, considerably more of which are known. From the early Byzantine period through to the Middle Ages, the two types of tables were believed to have been those employed in the Early Church for New Testament meals. They were revered by pilgrims to the Holy Land and were copied in the West. Among those surviving today, several are thought to be mediaeval copies, and these have the scalloped edging depicted in representations of such tables from the sixth century onwards.

The present table top has a simple rounded moulding at the edge. This was certainly a treatment for secular tables of late Roman date in use in Syria and Palestine, as is shown on the third-century mosaic from Antioch (Daphne)[1].

Description

The piece is large (diameter 124.5 cm) and appears to be in perfect condition. Indeed, it has a misleadingly new look since at some time, presumably recently, a mechanical polisher has been applied to the surface which no longer has any patina or obvious signs of age. However, close inspection shows several small pitted areas on the rim where the electric polisher could not penetrate. Here deposits and encrustations, consistent with antiquity, can easily be seen with a ×10 magnifying glass. These can also be seen in the 'valleys' of the incised lines of the rosettes which are narrower than the lines that form the Christogram; these, being wider, have not resisted the cleaning process. Fortunately the back has not been similarly treated and the regular marks of a hand tool can be seen here as well as sand-coloured earth staining. Both these signs are consistent with the attributed date.

The decoration consists of a relief-moulded edge (wherein a slim band in relief adjoins a rounded outer edge). Within this almost the entire diameter is taken up with an elegantly incised Christogram, that is, the monogram of Christ (*Chi-Rho*). The 'bulb' to the *Rho* is formed by a sinuous curving line, elegantly placed. Between the arms of its *Chi*, the letters *Alpha* and *Omega* – another Christ symbol of course – are delicately incised, with gently flaring 'serifs'. A rosette, forming a cross, is inscribed at the end of

each arm of the *Chi*. The design of these is unusual: they are bounded by paired concentric circles; each has a little circle at its centre and four oval petal shapes ending in a point make up the rosette. The petals are outlined three times, the innermost outline being complete to the point, the other two terminating at the boundary circle. This emphasises the effect of a cross.

Published Parallels for Early Christian and Byzantine Marble Table Tops

Attention was drawn to the circular Early Christian table top in 1951 when excavations at Salona, on the Dalmatian coast near modern Split (Spalato), brought to light several fourth-century examples which were thought by the excavators to have been used for Eucharistic meals in connection with the cults of various martyrs who had been buried at Salona.[2] These finds consisted of simple circular marble tables that were fairly large. They were without inscriptions but had a moulded edge resembling the one under discussion. There were also a number of smaller ones. These latter belonged to a group the majority of which were square in outline but with a circle inscribed, and in some cases sunk, within the square. One of these small tables has a *Chi-Rho* at its centre, though smaller in relative scale than the one on the present piece.

These smaller table tops are named in their inscriptions, as *piscinae*;[3] this is the same term as is used for baptismal fonts. This suggests a rich symbolism since the Christogram in a ring has a function suitable as a baptismal font, a Eucharistic table, and as a grave marker for martyrs and their devotees.

In 1955 the distinguished scholar Alphonse Barb discussed the circular altar table in connection with early representations of the Holy Grail.[4] His list of examples was reviewed in 1961 by O. Nussbaum[5] who listed eleven round altar tables, giving their current locations and some estimated dates. These were:

1. *Rhodes*; Museum; fourth century; a round table with a hunting-scene border.
2. *Constantinople*; Archaeological Museum; last quarter of the fourth century; a fragment of a table inscribed with a depiction of the Healing of the Blind.
3. *Donnerkirchen*; last quarter of the fourth century; a round table with scalloped edging.
4. *Besançon*; Cathedral; a table loosely dated between the ninth century and the eleventh century. This served as an altar table in the Middle Ages.
5. *Tebessa*; end of the fourth century; set into the floor of the Baptistry; scalloped edging.
6. *New York*; Metropolitan Museum; unknown provenance; a table decorated with two lambs and two Christograms.
7. *Salona*; a round table with no decoration. [He does not count the smaller *piscinae* from this site.]
8. *Carthage*; Musée Lavigerie de Saint-Louis; a fifth-century table; the rim is scalloped and there is an inscription: S + I DEUS PRO NOBIS QUIS CONTRA NO(S)
9. *Varna*; fifth century; a fragment with a representation of the Twelve Apostles.
10. *Lechaion* [his pl. 2b]; last quarter of the fifth century; found in a graveyard south of the apse in the basilica there.
11. *Delos*; (fifth century?); unknown provenance.

Nussbaum then lists fifty-three examples of the sigma-shaped altar tables. Many of these have scallops as do some of the round examples.[6]

In 1971 a Bulgarian archaeologist, Maria Cicikova, published a fragmentary round table uncovered at the Byzantine site of Nicopolis ad Nestum near Nevrokop in Bulgaria, on the Mesta River.[7] This table had no decoration at the centre but it did have a decorated rim with large masks and classical figures. Interestingly, this resembles arrangements on some items of the Mildenhall Treasure now in the British Museum. The piece is dated by Cicikova to between the end of the second century and the beginning of the fourth century.

At the time she was writing, Cicikova felt that there were now eighty-seven tables, or fragments of tables, known from this group (considering both round and sigma-shaped examples together): twenty-two found in Egypt and North Africa; six in Italy; two in Pannonia; three in Yugoslavia; eight in Bulgaria; six in European Turkey; seventeen in Greece and the Greek islands; nine in Asia Minor, Syria and Mesopotamia; and two more from around Cherson; the rest being from unknown locations. She felt that there were a number of workshops for them, but one important workshop may have been Salonika.

Parallels for the Decorative Style

The decorative style of the present table affords some clues. The slimly drawn Christogram with a closed top for the *Rho* is proper for the fourth century and the early part of the fifth. Towards the end of the fifth century the *Rho* is sometimes drawn with an open top.[8]

The petal-form cross enclosed with a circular ring is typical of a style of the cross combined with the star which was carved in Syria. Some examples, formerly in the Kaiser Friedrich Museum, Berlin (unfortunately undated), are illustrated by Oskar Wulff. They also appear carved in depictions of textiles on Byzantine ivory consular dyptichs of the early sixth century.

Symbolism and Function

The symbolism of the large Christogram on a disc accompanied by crosses is Eucharistic. The Eucharistic bread is very often depicted with a cross or a rosette with four petals inscribed on its top. Undoubtedly it was made thus from earliest Christian times.[9]

A round table placed near a sigma-shaped couch on which the diners reclined is quite common in early representations of the Last Supper. The group in this design seems to have been adapted to actual altar arrangements within churches in various ways. For instance, a round altar table was placed within a sigma-shaped apse, as discussed by Jean Lassus.[10] This placement of the altar table was most common in Syria where it may have followed Roman dining-room arrangements. This is likely since the Antioch (Daphne) secular Roman pavement, referred to above, certainly shows a round table placed within an apse-like space. The present table may have been once so placed within a church. Sometimes sigma-shaped altar tables themselves have circles inscribed

in their centres, which of course echoes this arrangement.

In fact, the notions of Christians concerning the shared Eucharistic meal of the Body of Christ among baptised Christians, and their idea of the resurrection of baptised Christians through Christ, were all equally symbolised, at this date, by the Christogram inscribed within a circle. It also signifies Paradise itself, and came to be shown in the centre of the Heavens. This can be seen in the chapel of the Archbishop's Palace, Ravenna, dated circa AD 500. Another example is in the Baptistry at Albenga, where it is depicted in ever widening rings of light emanating from the centre of a dark sky that is filled with golden stars and surrounded by doves.[11]

The Christogram

The *Rho* of this version is a closed loop. It is almost always shown thus in the fourth century rather than with an open loop which is the form noticeable from the beginning of the fifth century and which continues through the sixth century. In this later period the closed loop still sometimes occurs, though not usually on the more ostentatious representations of this sign.

I have only been able to locate the flourish at the top and bottom of the closed loop in fourth-century material. The clearest example is on the inscribed bowl of the Water Newton Treasure, now in the British Museum, which was buried in the earlier or middle part of the fourth century.

The arms of the *Chi* done with a single line, with simple 'serifs' at their ends, are not common in fifth- and sixth-century material but again occur in the fourth century. Examples are on some of the Water Newton silver-gilt plaques [12] and on a mosaic pavement from the villa of Hinton St Mary in Dorset. As we have seen in the case of the closed loop, the version of the arms done with a single line and without flares, when it occurs in later centuries, tends to be used on rather insignificant representations of the *Chi-Rho* sign such as on rings or spoons.[13]

All things considered, the *Chi-Rho* on this marble piece has a fourth-century feel.

Dating and Conclusion

The shape of the rosette indicates a date in the second half of the fifth century. But the *Chi-Rho* does have the slim-line elegance of the sixth-century arrangements though it is not the open *Chi-Rho* which had become widespread by that time. On the other hand, the closed loop of the *Rho* is typical of the fourth century. It is possible that further research may reveal a more precise dating.

M. W.

Notes

1. J. Lassus, 'Remarques sur l'adoption de la forme basilique pour les églises chrétiennes', *Atti del·III congresso internationale di archeologia cristiana - Ravenna 1932*, Rome, 1934, pp. 335ff.

2. Eynnar Dyggve, *History of Salonitan Christianity*, Oslo, 1951.

3. Ibid., pp. 106, 107.

4. A. Barb, '*Mensa Sacra*, The Round Table and the Holy Grail', *Journal of the Warburg and Courtauld Institutes*, XIX, 1955, pp. 40ff.

5. O. Nussbaum, 'Zum Problem der rundem und

sigmaformigen Altar-platten', *Jahrbuch für Antike und Christentum*, 4, 1961, p. 188.

6. Ibid., pp. 37–8.

7. M. Cicikova, 'Mensa Sacra de Nicopolis ad Nestum', *Bulletin de l'Académie Bulgare des Sciences*, XXXIII, Sofijia, 1972, p. 257ff.

8. Marian Wenzel's MS illustrates two examples from Spain. She comments: 'Others are not difficult to find.'

9. The MS here has two sketches by Marian Wenzel showing part of a depiction of Abel and Melchizidek

prefiguring the Eucharist – at a sigma-shaped altar – with bread of this design, based on a sixth-century mosaic from San Vitale, Ravenna.

10. Lassus, op. cit.

11. Lars-Ivar Ringbom, *Graltempel und Paradies*, Stockholm, 1951, p. 305.

12. See ills. a and b in K. S. Painter, *The Water Newton Early Christian Silver*, London, 1977, pp. 14, 36.

13. K.S. Painter, *The Mildenhall Treasure*, London, 1977, p. 32.

STELAE

A 'stele' is a type of funerary monument that was particular to early Christian Egypt. Their function was, like that of the Fayum portrait (the precursor of the icon), to commemorate the dead and to appeal to the gods for assurance of the safe journey of the deceased into the next world. The figures represented on each stele are wide-eyed and attentive. This characteristic quality reflects the belief that the soul survives after the death of the body.

16. Stele
Egypt
5th–6th century
51 × 28.5 cm

There are traces of original pigment on this stele.

17. Stele
Egypt
5th–6th century
37.6 × 25.5 cm

The figure wears a medallion round his neck. This may relate to sun-worship. In ancient Egypt, the sun was commonly associated with transcendence of death. The upper corners of the stele have been cut away.

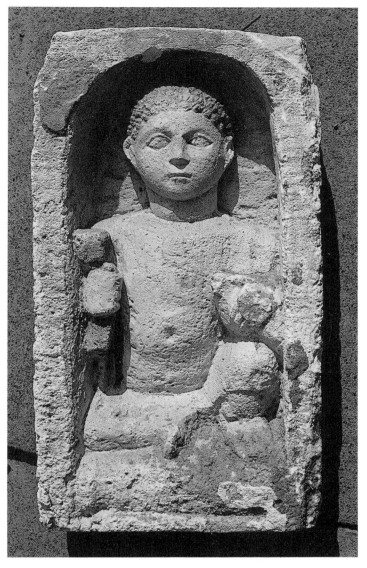

Cat.16

17a. Stele
Egypt
5th–6th century
42 × 22 cm

The figure represented holds a bunch of grapes in one hand and a dove in the other. The grapes are symbols of fertility and regeneration and the dove is a symbol of eternal peace.[1]

Note

1. For a similar stele with description, see K. Wessel, *Koptische Kunst*, Recklinghausen, 1963, col. pl. V, p. 103.

18. Frieze with Trees and Birds

Byzantine
Late 5th or early 6th century
Limestone, 58 × 200 cm
Illustrated in colour on page 24

The carving is set between two horizontal borders running the full length of the frieze. The lower border is set well above the edge of the stone while the upper border is less wide. The space is interspersed with trees on the leafless branches of which sit birds in various positions but all facing left. Birds are also standing on the ground and facing left. They are in different postures and, curiously, of different sizes though all of the same species. The right-hand bird's lively and spontaneous movement is characteristic and it is not difficult to identify them as doves, the symbol of spiritual purity adopted by Christianity from ancient tradition. They are well carved in high relief and are preserved in good condition.

Describing the piece,[1] Wessel suggests that it is an architrave and compares it with the well-known 'Lamb Frieze' found during the excavation of the atrium of Hagia Sophia at Istanbul.[2] He says that the birds themselves gives clues to the dating since they can be related to a significant number of other datable representations. From the 'mass of examples' he cites:

The sarcophagus of Archbishop Theodorus of the mid fifth century at Sant

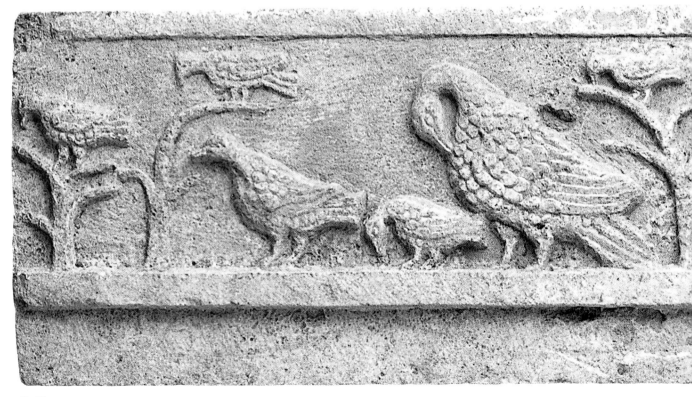

Cat.18

Apollinare in Classe in Ravenna. The pairs of doves at the narrow ends of the sarcophagus show a close resemblance to our birds.[3] Here there is also another sarcophagus decorated in a similar way with peacocks.

Fragments from the church of St Menas in Thessalonica where birds 'of similar lively posture and plumage' are found.[4]

On the choir screen in St Apollinare Nuovo in Ravenna (dated AD 520) there are also peacocks carved in similar style.

There is a similar fragment, though a little larger, in the Archaeological Museum at Iznik in Turkey dated to the sixth century.[5]

In addition to the examples cited above, Wessel considers a tall carved stone slab from a screen of the Justinian period in the Berlin State Museum, which has 'exactly the same head feathers and similar wing feathers'.[6] On the basis of these comparisons he dates our frieze to the 'first half of the sixth century or possibly the end of the fifth century'.

Notes

1. Neufert Galerie Catalogue, Munich, 1978, no. 15.

2. See A. Grabar, *Sculptures Byzantines de Constantinople IVe–Xe siècle* Paris, 1963, pl. XV, 1.

3. See Bovini, *Sarcofagi Paleocristiani di Ravenna*, Citta del Vaticano, 1954, fig. 33.

4. See Grabar, op.cit., pl. XXIV.

5. See T. Ulbert *Untersuchungen zu den Byzantinischen Reliefplatten des 6 bis 8 Jahrhunderts*, Istanbuler Mitteilungen 19/20, 1969–70, pp. 339ff., fig. 67, 4.

6. See S. Bettini, *La Scultura Byzantina II*, Firenze, p. 5.

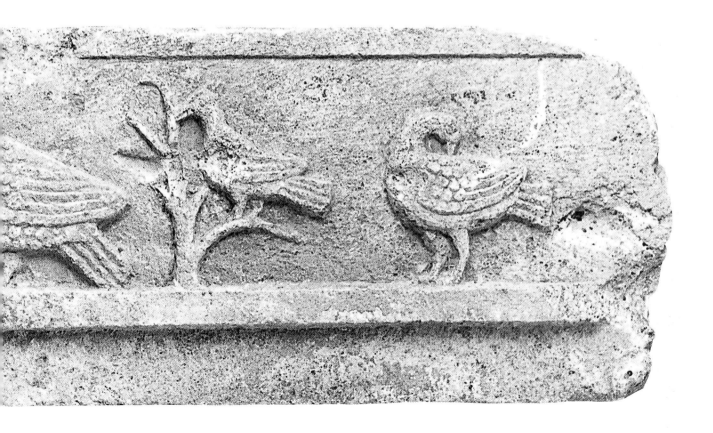

19. Limestone Cross

Syria
6th century
83.8 × 72.4 cm

The arms of the cross are decorated with a laurel branch pattern. They are slightly flared at the ends. This feature is characteristic of Byzantine crosses and it became more pronounced in later centuries (see nos. 65, 66). The centre point of the cross is marked by a rosette containing a six-pointed star. Deep notches in the arms of the cross suggest that it was originally mounted and secured in a wall setting.

A. S.

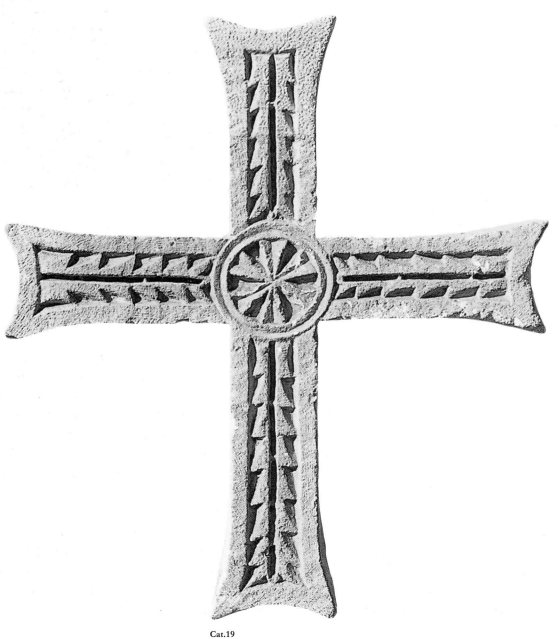

Cat.19

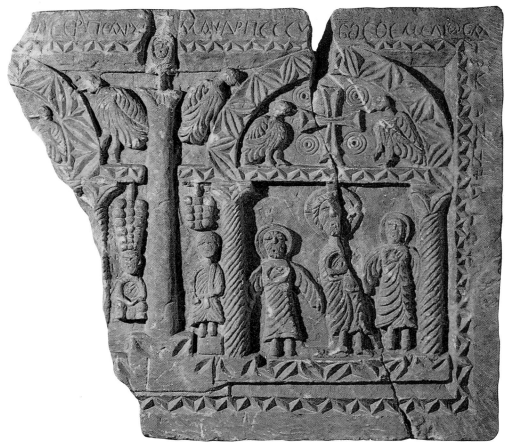

Cat.20

20. Stone Relief with Christ and Angels

Syria
6th century
Limestone
81 × 89 × 16.5 cm

The relief probably belongs to the very small number of fragments of Syrian figurative sculpture that are known to have come from church buildings or archaeological finds. It may well come from the low screen that conventionally functioned as a division between the sanctuary and the main body of an early Christian church. These divisions often consisted of a low balustrade, or a wall made up from carved or otherwise decorated panels and topped with columns. The iconostasis screen developed from this type of partition and therefore, if the relief was originally conceived for such a position, it could rightly be regarded as a precedent for the iconostasis.[1]

The well-preserved part of the relief on the right shows Christ between two angels beneath an arcade. The arcade consists of two columns engraved with a spiral pattern and with a simple leaf design on the capitals, an architrave with a deeply engraved zigzag pattern, an arch with a series of leaves (also arranged in a zigzag pattern) and a tympanum. The tympanum contains a cross between two birds, both facing the centre. The species of bird cannot be identified. In each of the spaces between the arms of the

cross, there is a circle-and-dot ornament. The architrave projects out to the left above the column, and a bunch of grapes hangs down from it. Beneath the bunch of grapes, a figure without a halo stands on a small platform. This section of the relief is separated from its badly damaged neighbour by a smooth column. On top of the leafy capital of this column, there stands the bust of a monk(?) supported on a short staff.

Of the second section of the relief, only very little of the arch survives. It is evident from what remains that the design of this section must have been similar to that of the first section. The architrave projects to the right and a rather larger bunch of grapes hangs down as far as the head of a small seated figure, also without a halo. Both sections were surrounded by an ornamental border, which follows the same pattern as that on the architrave. Along the top edge of the relief there is a partly preserved Greek inscription, which names an archimandrite as the founder of the church. Unfortunately only a fragment of his name remains and it is not possible to complete it.

Apart from the almost total destruction of the left section of the relief, there is a crack running throughout the right part, resulting in the loss of a wedge-shaped piece of stone from the top. Part of the inscription is missing at this point. The crack also runs through the arch of the archivolt and slightly damages the head and shoulder of the figure of Christ.

From the point of view of iconography, we should observe the special feature of rings circling the hands of Christ and the angels. This detail clearly originates from an ancient style used to portray philosophers and masters of rhetoric, and which was sometimes adopted in representations of Christ. See, for instance, the fragment from Psamatia (Istanbul) in the Bode Museum in East Berlin. It is also unusual that the angels beside Christ are bearded. Although this detail is rare, it does sometimes occur in provincial iconography. An ivory carving of the baptism of Christ in the British Museum includes this detail. It has been suggested that the two figures without haloes may represent donors.

The relief probably consisted of only two sections, in which case the smooth column with the figure on top of it would represent the central axis. This was the normal format for such reliefs. The significance of the central figure is unclear. We could conjecture that it represents a stylite (see catalogue no. 86). Despite the absence of a halo, the cross suspended above his head is a point in favour of this theory.

The only works that can be closely related to this piece are six stone reliefs from Rasm al-Qanafez in the Damascus Museum.[2] The ornamentation of our relief and the angels' wings in particular, as well as the striking primitive appearance of the stone masonry, are details that are shared with these other pieces.

Nasrallah has estimated that the Damascus reliefs should be dated to the end of the sixth century. Owing to lack of conclusive evidence, this date must remain hypothetical. In any event, the Damascus reliefs and the relief discussed here must be works that date from a time either before or shortly after the Arab conquest.

K. W.

Notes

1. See *7000 Jahre Anatolische Kunst*, Istanbul, 1983.

2. See J. Nasrallah, *Bas-reliefs Chrétiens Inconnus de Syrie*, XXXVIII, Syria, 1961, p. 44ff., pls. III, IV.

21. Nereid with Fish

Coptic
4th–5th century
Limestone
20 × 29 cm

The relief depicts a naked nereid (a sea-nymph) reclining on a large fish. She holds a cloth above her head. It is most likely that she represents a river goddess. Although the presence of pagan iconography in Coptic art originally reflected the continuation of classical religious values into the Christian way of life, such figures eventually came to serve a decorative purpose without ritual significance.

The relief was originally set in a raised position at the top of a niche.[1]

A. S.

Note

1. For a series of lamps and lamp moulds with comparable designs, see *Spätantike*, nos. 101–24.,

Cat.21

22. Two Fragments of a Marble Relief

Northern Italy
9th century
Marble
a: 49 × 59 cm
b: 47 × 58.5 cm

Both fragments of the relief depict a peacock feeding from a palmette. The two pieces are almost identical mirror images of each other and clearly formed part of the same large relief. Their condition is good. Their regular shape and the clean cut of their edges suggests that they were sawn and not broken. In each case the palmette is resting on the capital of an Ionic column, only a very small part of which survives.

Cat.22

Symmetrical pairs of peacocks like these are often found on the sides of altars or church walls.[1] The same motif was used on sarcophagi,[2] and can be seen on fragments of ancient pulpits from Voghenza now in the museum of Ferrara.[3]

These selected examples originate from the period from the fifth to the ninth century and from the domain of Byzantine and provincial Byzantine art, including the 'Langobardic' style in Italy. Both the fragments under consideration here could come from a marble wall relief, although they would be unusually thin in that context. It is more likely that they formed part of a decorative relief like that of the small metropolis in Athens,[4] which is a good example of a symmetrical design in two zones (which we may assume was the original setting for these two fragments).

As for the date of the fragments, they belong with the later specimens on the list of examples we have given (see Notes below). The method of carving the relief at only two levels of depth is the first proof of this: the background of the relief has been cut into the original marble and the images are left to stand out. The details of the images are then cut into their surfaces, so that the most important parts of the relief are all equally prominent in the foreground. This relief technique is no longer late antique but is rather early mediaeval. One of the earliest examples of this technique of carving is the sarcophagus of Archbishop Ecclesium (AD 532) in San Vitale in Ravenna.[5] Even here there are traces of the earlier inclination to compose a design from solid blocks.

Owing to the wide variety of styles and techniques used throughout the early Middle Ages, we should not expect to find any reliefs which will match the style of the present reliefs exactly. Nevertheless, parallels can be found for a number of their individual features of style, and we can determine from these approximately when and where the reliefs were made. The woven pattern, for instance, used to represent neck feathers, is found on two reliefs in the Archaeological Museum in Istanbul.[6] See also a decorative relief in the Archaeological Museum in Iznik[7] and a fragment in the Basmane Museum, Izmir.[8] These pieces have all been dated to the eighth century. A similar relief may be seen in the church of St Gregory in Thebes which was dedicated in

AD 872.[9] The double-level treatment of the relief in the latter piece is particularly close to the two fragments. It also demonstrates a symmetrical design in two zones. A comparable way of depicting birds' feathers can be seen in the ornamental jewellery of the church of Skripu, dated AD 873–4.[10]

The unusual contours of parts of the feathers can also be seen in a pulpit fragment from Serrhes[11] and in a wall relief in Santa Maria Trastevere, Rome, from the eighth century.[12] The fluted pattern on the wing feathers occurs in a similar form in the symbol of the evangelist Mark (a winged lion) on a wall relief in the Callixtus Baptistry in Cividale dating from the years 762–76.[13] The form of the eyes and the greatly reduced crown of feathers can be compared to those of the peacocks on a ninth-century marble relief from the church of Santa Maria del Popolo in the Museo Civico Malaspina in Pavia.[14]

The form of the leaves also has parallels; for instance, on an eighth-century sarcophagus from the church of San Vittore in the Museo Nazionale, Ravenna[15] on which we also find a central stem with the two rings and the point at the top, and on a capital of the ninth- to tenth-century parish church of Aquaiura.[16] Rather less similar, but still with the same basic features, are the fragments from the ninth-century church of San Giuliano in Spoleto.[17] These comparisons bring us into the ninth century, but it is difficult to give a more accurate date. Since some features of the craftsmanship in these fragments can be closely paralleled with monuments of Langobardic art in Italy and Ravenna, it seems likely that they come from the region of so-called Langobardic art, rather than from the provincial regions of the Byzantine Empire in the Balkans. The place where the fragments were found suggests that they were from northern Italy.

K. W.

Notes

1. For example, see S. Bettini, *La Scultura Bizantina II*, Florence, p.5 (Berlin State Museum and Athens, the small metropolis); p. 15 (Sofia Archaeological Museum); p.27 (Torcello Cathedral).

2. Examples are illustrated in Bovini, *Sarcofagi Paleochristiani di Ravenna*, Citta del Vaticano, 1954, figs. 29, 32, 40 and 55; also in A. Haseloff, *Die Vorromanische Plastik in Italien*, Berlin, 1930, fig. 40 (the sarcophagus of Theodota in the museum in Pavia).

3. See Haseloff, op. cit., fig. 52. For other parts of church interiors see Haseloff, fig. 59 (a reliquary in Santa Maria in Aventino, Rome). Cf. also A. Grabar, *Scultures Byzantines de Constantinople (IVe–Xe siècle)*, Paris, 1963, pl. XLIII, 3 and 4 (the church of St Gregory in Thebes, Greece) and Bettini, op. cit., p. 5 (the funeral stele of Julia Primilla in the museum in Mursa).

4. Bettini, op. cit., p. 14.

5. Bovini, op. cit., fig. 55.

6. See T. Ulbert, *Untersuchungen zu den Byzantinischen*

Reliefplatten des 6 bis 8 Jahrhunderts, Istanbuler Mitteilungen, nos. 19 and 20, 1969–70, pp. 339ff., fig. 73, 1 and 3.

7. Ibid., fig. 74, 2.

8. Ibid., fig. 74, 3.

9. See Grabar, op. cit., pl. XLIII, 4.

10. Ibid., pls. XXXIX, 1; XLI, 2; XLII, 7.

11. Ibid., pl. XXXVIII, 3.

12. Haseloff, op. cit., fig. 61.

13. See E. Schaffran, *Die Kunst der Langobarden in Italien*, Jena, 1941, fig. 30a.

14. See G. Panazza, *Lapide e Sculture Paleochristiane e Preromanische de Pavida, Arte del Primo Millenio*, Turin, pp. 221ff., no. 130, fig. CXXI.

15. See Bovini, op. cit., fig. 64.

16. See J. Serra, *Corpus della scultura altomediaevale II, La Diocesa di Spoleto*, Spoleto, 1961, fig. 1a.

17. Ibid., fig. LIV.

TILES

23. Tile with Amphora and Birds

North Africa
5th–6th century
Terracotta
38 × 32 cm
Illustrated in colour on page 23

Cat.23

The composition of this tile is dominated by a large amphora between two columns. Above it, a large pediment encloses the *Chi-Rho* monogram; *Alpha* and *Omega* appear between the arms of the monogram. Two birds are perched above it at the top.

The motif of a pediment supported on two columns recurs frequently in early Christian art. It was based on the traditional location and context of the imperial throne in the emperor's palace and became so closely associated with the presence of the emperor that it was used to represent him in his absence. The related image of the *Heitomasia*, the imperial throne made ready for the Second Coming of Christ, is based on the same association. Compare this with St George, no. 7, detail, centre top see p. 15.[1]

Note

1. See also Weitzmann (ed.), *The Age of Spirituality*, New York, 1977, p. 62, fig. 11.

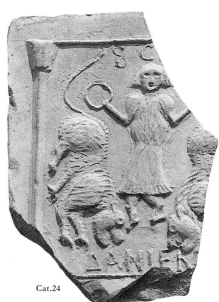

Cat.24

24. Tile

with Daniel in the Lions' Den
5th–6th century
North Africa
Terracotta
25.9 × 18 cm

Daniel stands in the *orans* posture at the centre of the tile. He is holding a large ring in his right hand. To each side of him there is a lion. Their prostrate positions indicate that they have become harmless. At the top of the tile there is the remains of an inscription beginning: SC . . . ; at the bottom, the inscription reads: ΔΛΝΙΕΛ (DANIEL). For a consideration of the iconography of Daniel, see catalogue no. 38. The scene is framed by a ridge at the top and an undecorated column and capital to the left.

POTTERY

25. Bowl
Byzantine
12th century
Glazed earthenware
Diameter: 20.4 cm

The bowl is decorated on the inside with engraved patterns. The encrustations on its exterior suggest that it has been wrapped in cloth for many years and at some occasion was preserved under water.

Cat.25

26. Fragment of a Plate
with the Serpent and the Tree of Knowledge
North Africa
4th–5th century
Terracotta
Length: 14.4 cm
Illustrated in colour on page 23

From the large number of surviving pieces, it is possible to establish that one or more workshops producing distinctive burnished earthenware vessels and lamps flourished in North Africa from the end of the fourth century. These wares were distributed all over the Mediterranean world. Plates and bowls were shaped from gypsum moulds; shallow reliefs were then applied to the inside surfaces of the vessels before firing. It seems probable that this appliqué technique evolved in order to imitate the lavish silverware that was being produced at the same time for more affluent clients.

The scenes represented on such pieces include biblical scenes as well as popular stories from pagan cult religions and mythology. The variety of subject matter suggests that this particular workshop served many different clients, regardless of religious affiliation; this in turn may explain why the workshop flourished and why such a large number of their works survive. The fact that so many examples of this work have been found in ancient cemeteries suggests that they may originally have had a sepulchral function.

The present fragment formed part of the rim of a large plate with a diameter of approximately 35 cm. The image represents the serpent in the Garden of Eden, entwined around the Tree of Knowledge.[1]

A. S.

Note

1. for similar plate fragments with almost identical decoration, see *Spätantike zwischen Heidentum und Christentum*, Munich, 1989, no. 50 and 51.

Cat.26

OIL LAMPS

Oil lamps of many kinds survive from the early Christian period, of which a number are splendid and elaborate examples. By far the most common, however, are the simple household lamps. These were made of clay and were shaped from gypsum moulds (see nos. 40, 41 and 42).

Most of the lamps here were made of red earthenware clay and were fired at a relatively low temperature. A red slip glaze was used to give them a finish and to make them non-porous. The basic form of the lamps is a covered bowl, with holes in the top for oil, and an extended spout, at the end of which is a large round opening for the wick. Usually a vegetable oil was used and the wicks were made of some fibrous material like hemp. Simple protrusions at the other end of the lamp serve as handles. In making a lamp, the clay was given its fundamental shape from the mould and was finished by hand when firm. On most lamps it is possible to see where the junction of the two halves has been worked. The oil and wick openings will also have been opened up at this stage.

The central area of this kind of lamp was decorated with a figurative motif surrounded by a patterned border. The subject matter in this area includes biblical, mythological and other decorative or symbolic themes.

Although examples of these types of lamps are to be found all round the Mediterranean, most of the present examples come from North Africa, probably Tunisia, and date from the fourth to the fifth century.

The other type of lamp represented here has a ring handle supporting a cross, and a single opening at the centre for oil. The spouts of these lamps splay open at the ends. This type occurs most frequently in bronze, which is not particularly well suited to the effect of shallow relief decoration.[1]

A. S.

Note

1. For a collection of similar lamps, see *Spätantike zwischen Heidentum und Christentum*, Munich, 1989, nos. 140–9, 158–79 and elsewhere; colour plate on p. 76.

Cat.27

27. Oil Lamp with Geometrical Decoration

Syria
5th century
Terracotta
Length: 12 cm

The lamp has a ring handle decorated with a cross. The body is decorated with simple symmetrical lines.

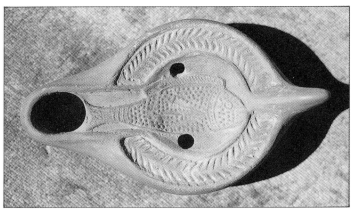

Cat.28

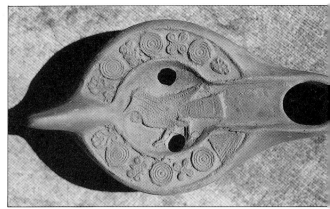

Cat.29

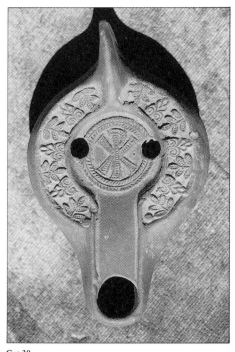

Cat.30

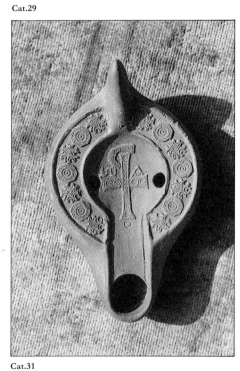

Cat.31

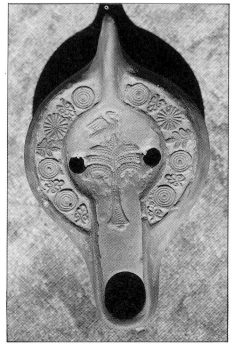

Cat.32

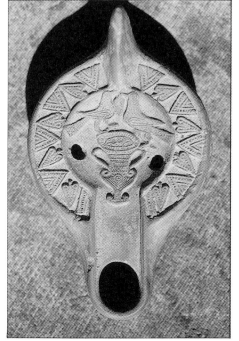

Cat.33

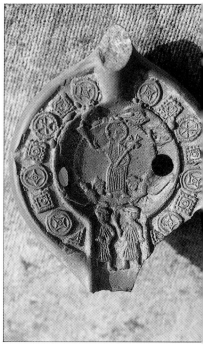

Cat.34

28. Oil Lamp with Fish Decoration
North Africa
4th–5th century
Terracotta
Length: 14 cm
Illustrated on page 80

The central area of the lamp is decorated with a large fish. The fish was one of the most widespread of early Christian symbols. It owes its popularity to the fact that the Greek word for fish – ICHTHUS – is an acronym comprising the opening letters of the words **I**esus **C**hristos **TH**eou **U**ios **S**oter', meaning 'Jesus Christ, Son of God, Saviour'.

The fish features regularly in the miracles of Christ. At the Feeding of the Five Thousand, for instance, it is a prototype for the Eucharist. The luminous fish-shaped aura of Christ is sometimes called the *vesica* or fish.

The border around the fish is decorated with a chevron design.[1]

A. S.

Note

1. For comparable examples, see *Spätantike*, nos. 168, 169.

29. Oil Lamp with Bird Decoration
North Africa
4th–5th century
Terracotta
Length: 14.4 cm
Illustrated in colour on page 22

The lamp is decorated with a bird. As is the case with almost all early Christian symbols, the archetypal significance of the bird was recognised long before the days of Christianity. The type of bird depicted in this example cannot be identified. It is distinguished from the dove by its complex plumage and long pointed beak.

The border is decorated with a pattern of concentric circles.

30. Oil Lamp with Chi-Rho Decoration
North Africa
4th–5th century
Terracotta
Length: 14 cm
Illustrated on page 80

The lamp is decorated with the *Chi-Rho* monogram which consists of an **X**

superimposed on a R. Using the first two letters of the name of Christ (in Greek), this sign was used throughout the early Christian period.

The border is decorated with tree forms.[1]

Note

1. See *Spätantike*, no. 159 for comparable bird decoration and no. 164 for the border design.

31. Oil Lamp with Chi-Rho Decoration
North Africa
4th–5th century
Terracotta
Length: 13 cm
Illustrated on page 80

The lamp is decorated with the *Chi-Rho* monogram (see catalogue no. 30). In this example, the craftsman mistakenly incised the original image in the positive rather than in the negative and thus the *Chi-Rho* monogram appears in reverse. There is also an A above the left arm of the cross and an ⚌ above the right arm. These are *Alpha* and *Omega*, the first and last letters in the Greek alphabet and they are used to indicate the fullness of Christian revelation (The Revelation of St John the Divine 21, 6). The letters should also be the other way round.

The border is decorated with alternating rosettes and octagons.[1]

Note

1. For a series of lamps and lamp moulds with comparable designs, see *Spätantike*, nos. 101–24.

32. Oil Lamp Decorated with a Bird in a Tree
North Africa
4th–5th century
Terracotta
Length: 14.6 cm
Illustrated on page 80

The theme of a bird in a tree is, like so many early Christian symbols, an archetypal image that predates Christianity in its origin. The tree is traditionally recognised as a symbol for the primary growth of life out of primordial consciousness. Birds, as symbols of the human soul, are often represented resting in its branches, nourished at the source of life.

The image was frequently represented in early Christian art. The same iconography can be seen in our architrave, no. 18, and in the celebrated late fourth- or early fifth-century ivory carving of the Ascension in the Bayerisches National-museum, Munich.[1]

Note

1. See Beckwith, *Early Christian and Byzantine Art*, Harmondsworth, 1970, pl. 37.

33. Oil Lamp Decorated with Two Birds and an Amphora
North Africa
4th–5th century
Terracotta
Length: 14.3 cm
Illustrated on page 80

Like the bird in the tree, birds drinking from an amphora (a classical two-handled vessel like a trophy) is a variation on the theme of the replenishment of the soul at the source of life.[1]

Note

1. For a second lamp, taken from the same mould, see *Spätantike*, no. 166.

34. Oil Lamp Decorated with Ascension of Christ
North Africa
4th–5th century
Terracotta
Length: 10.2 cm
Illustrated on page 80

Although this lamp is damaged, the area on which decoration occurs is well preserved. At the centre of the lamp is the ascending Christ holding a staff in the form of a cross. Two angels in flight stretch a cloth beneath his feet. Above Christ appear the signs of the four evangelists: an eagle for St John, an angel for St Matthew, a bull for St Luke and a lion for St Mark. The 'two men in white', as described in Acts 1, 10–11, stand beneath Christ.

The border is decorated with circles and squares.[1]

Note

1. For a second lamp, taken from the same mould, see *Spätantike*, no. 86 and colour ill., p. 76.

35. Lamp Decorated with Cross
North Africa
4th–5th century
Terracotta
Length: 9.8 cm

36. Lamp Decorated with Cross
North Africa
4th–5th century
Terracotta
Length: 9.5 cm

37. Lamp Decorated with Cross
North Africa
4th–5th century
Terracotta
Length: 8.9 cm

On the bottom of the lamp a miniature impression of a foot probably indicates the workshop in which the lamp was made. It has been suggested that the sign of a footprint has funereal implications, indicating a trace of a life that has passed. According to the psychologist W. Stekel, 'This sombre symbolism is illustrated, possibly, in the monuments characteristic of the Roman Empire, and beyond question, in primitive Christian art . . . '.[1] The footprint of a spiritual teacher was traditionally revered in ancient religious societies and at the beginning of this century, under the influence of Eastern religions, the Orthodox Church sanctioned the veneration and representation of the last footprint of Christ before the Ascension in icons.[2]

Notes

1. Quoted in Cirlot, *A Dictionary of Symbols*, London, 1962, p. 106.

2. Cf. Christie's, London, 7 November 1989, lot 23.

38. Lamp Reflector with Daniel in the Lions' Den

North Africa
4th–5th century
Terracotta
Length: 8.9 cm

Some terracotta lamps were made with screens above the handles to catch the light and to shield the hand from the flame. Such a feature also appears modified as a decorative device in bronze lamps (cf. no. 47) and in some pottery lamps (cf. no. 27).

The present example is decorated with Daniel in the Lions' Den (Daniel 6, 16–23). Daniel appears in the *orans* posture at the centre of the disc, with a lion to each side of him. This was a popular subject in early Christian iconography. Daniel was primarily depicted in the context of funerary art. As is the case with the prophet Jonah (who was swallowed by a whale and regurgitated on dry land three days later) Daniel's 'victory' over the lions was regarded as a prototype for the Resurrection of Christ.

The intermittent persecutions that impeded the growth of Christianity during the first five centuries AD made Christians fully aware that to embrace the Christian faith could mean a choice between life and death. Some concern for the subject of death is reflected in the earliest Christian iconography in which Daniel and other figures known to have been gracefully delivered from death (such as Noah, Isaac and Lazarus) feature prominently. Examples of this type of iconography can be seen on numerous sarcophagi and in the catacombs.[1]

The border is decorated with concentric circles. The junction point of the reflector can be seen on the back.

Notes

1. See A. Grabar, *Christian Iconography: A Study of its Origins*, London, 1969, pp. 10, 11.

2. For similar lamp reflectors, see *Spätantike zwischen Heidentum und Christentum*, Munich, 1989, nos. 150–4

39. Lamp Reflector Decorated with Bust Profiles

North Africa

4th–5th century

Terracotta

Diameter: 6.2 cm

Two classical-style bust profiles (of a man and a woman) appear on the front of the disc, superimposed on the *Chi-Rho* monogram (see catalogue no. 30). Objects decorated with bust profiles of this kind were commonly given as wedding gifts. The *Chi-Rho* monogram was included in this context to serve as a blessing for the marriage.[1]

The border is petalled.

Note

1. Examples of wedding rings with the same iconography are published in Vikan, 'Early Christian and Byzantine Rings in the Zucker Family Collection', *Journal of the Walters Art Gallery*, no. 45, 1987, p. 34.

Cat.39

LAMP MOULDS

Lamp moulds were made from gypsum, the mineral from which plaster of Paris is made. They originally consisted of a top and a bottom part that interlocked by means of a number of protrusions and depressions on the rims of the moulds. As it is only the top part of the mould that is decorated, it is often only the top part that has been preserved. In these examples the depression can be seen round the broad rim of the mould.

Dry gypsum is a brittle material and therefore many impressions could be taken from a single mould.

40. Lamp Mould Decorated with Chi-Rho
North Africa
4th–5th century
Gypsum
Length: 19.9 cm

The *Chi-Rho* monogram is represented in negative form at the centre of the mould in order to appear positively on the lamp. The border is decorated with chevrons.

41. Lamp Mould Decorated with a Bird on an Amphora
North Africa
4th–5th century
Terracotta
Length: 20.5 cm

The lamp mould is decorated with a bird standing on top of an amphora. In early Christian iconography this image symbolised the regeneration of the soul at the source of life. The border is decorated with triangles and arches.

42. Lamp Mould Decorated with a Fish
4th–5th century
Terracotta
Length: 17.1 cm

A fish is represented at the centre of the lamp. The border is decorated with triangles and circles.[1]

Note

1. For similar lamp moulds, see *Spätantike zwischen Heidentum und Christentum*, Munich, 1989, nos. 111, 113, 114.

43. Gypsum Mould of a Dove
North Africa
4th–5th century
Gypsum
Length: 25.6 cm

BRONZE

44. Chain from a Polycandelon

Byzantine
6th–7th century
Bronze
Length: 162 cm
Illustrated in colour on page 22

The chain includes two crosses, each decorated with a series of concentric rings. The Greek letters A and Ѡ (*Alpha* and *Omega*) form part of the lower cross. A smaller chain hanging from the Ѡ will originally have supported a further cross.[1]

Note

1. For comparable metalwork, see M. C. Ross, *Catalogue of the Byzantine and Early Mediaeval Antiquities in the Dumbarton Oaks Collection*, vol. 1, Washington, 1962, no. 44, pl. XXXI.

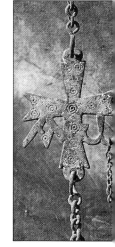

Cat.44

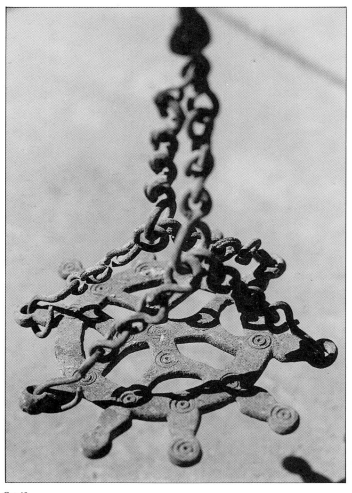

Cat.45

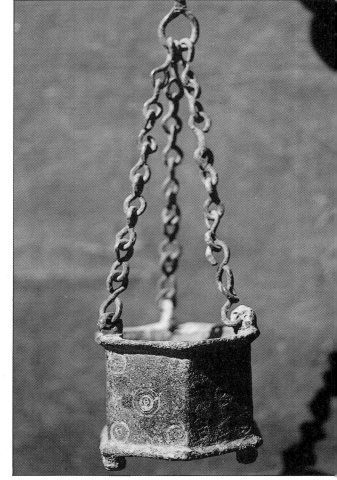

Cat.46

45. Fragment of a Polycandelon

Byzantine
10th century
Bronze
Diameter: 15.3 cm

The polycandelon was a predecessor of the chandelier. It usually consisted of a large pierced round plate, cast in bronze, hanging from a smaller bronze disc, which was suspended on chains from the vault or ceiling of a church. The present fragment comprises the smaller central disc. It is decorated with a series of concentric rings.

46. Bronze Incense Burner

Syria
6th century
Width: 6.2 cm

The incense burner is hexagonal and is decorated with concentric rings.[1]

Note

1. For comparable pieces, see Ross, op. cit., nos. 45 and 48, pls. XXXII and XXXIII.

47. Bronze Lamp

Byzantine
5th–7th century
Length: 14 cm
Illustrated in colour on page 22

As bronze lends itself more readily to detailed workmanship than clay the more elaborate lamps of late antiquity and the early Christian period are made of bronze. The present example was originally made to be mounted on a bronze stand, for which a fixture point is visible at the base of the lamp. The ring handle and cross and the splayed spout are typical of Byzantine bronze lamps. The lid over the opening for oil is missing. Other bronze lamps of the period indicate that the lid would originally have been in the shape of a scallop shell. The scallop shell is an example of how some classical imagery was absorbed without alteration into early Christian iconography.[1]

Note

1. See also *Byzantium: Light in the Age of Darkness*, New York, 1989, no. 26.

RELIQUARY CROSSES

From approximately the sixth until the ninth century, pilgrims to the Holy Places were able to acquire reliquary crosses as souvenirs of their visit. These crosses were made of two separate parts designed to enclose a central space in which a relic – believed to be a fragment of the true cross – was contained. They are hinged at the top and could be fastened at the bottom with a pin. They were designed to be worn around the neck.

The crosses come from Asia Minor or Palestine. They were made in large numbers, mostly of bronze. Bronze is an alloy of copper and tin but the term is used generally today to refer to all alloys of copper. The Byzantines inherited the rich copper mines of Asia Minor and the Balkans from the Romans and they continued to work them for several centuries.

Bronze objects were cast either directly from a mould or by means of the lost-wax process. The lost-wax process begins with the modelling of the object in wax; the object is then encased in clay which is left to dry. The wax is then melted and poured out through holes in the clay mould which is then filled with molten bronze. As the bronze cools it becomes solid and the clay mould is broken leaving the bronze object.

Their decoration was usually engraved on to the cross but, in some cases, it was also created from the case (cf. cat. no. 49). In some examples only one side of the cross is decorated with figures. On the backs of this type, geometric patterns are found with settings for glass gems or precious stones.

The iconography most commonly found on these crosses is Christ crucified, the Mother of God or a saint. The Mother of God and the saints are always represented in the *orans* position – the ancient position of prayer in which the arms are raised at the side of the body. (The word *orans* means 'appealing' or 'petitioning'.) Busts of the apostles are often depicted in roundels at the extremities of the cross. The names of the figures are usually inscribed on the arms.

A collection of similar reliquary crosses can be seen at the British Museum.

A. S.

Note

1. See also *Early Christian and Byzantine Art*, Walters Art Gallery, Baltimore, 1947, nos. 299, 302, 305, pls. XXXVIII, XLVI; *Byzantium: Light in the Age of Darkness*, New York, 1989, nos. 70–4.

The Virgin 'Orans'

In representations of the Virgin in the *orans* position, Christ is usually represented in a mandorla at her breast. This image first occurs in the fourth century. In the following century the emperor Leo I (457–74) and the empress Verina had a church built near the convent of Blachernae in Constantinople to house a holy relic of the Mother of God. This relic was the long, hooded tunic called the *maphorion*. The icon type of the Panagia ('All Holy') Blachernitissa originates from this time. In this image, the Virgin is represented wearing the *maphorion*. In Byzantine and later icon painting, the *maphorion* is always decorated with three golden stars. These symbolise the virginity of the Mother

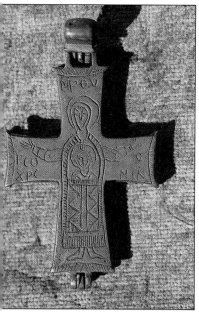

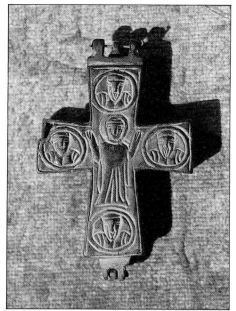

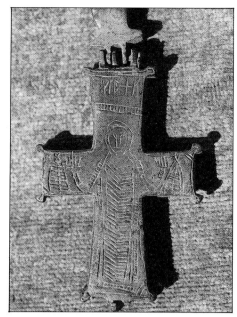

Cat.49

Cat.50

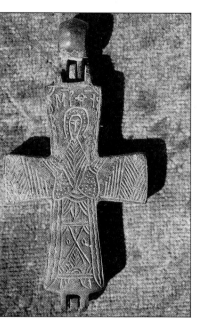

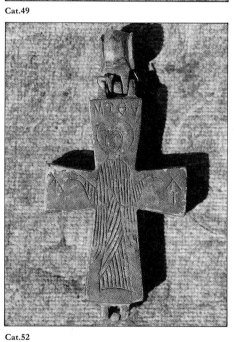

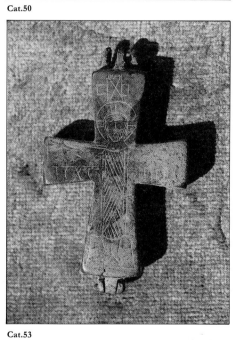

Cat.52

Cat.53

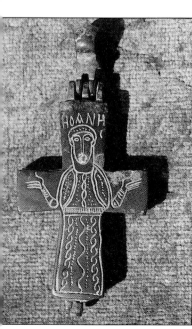

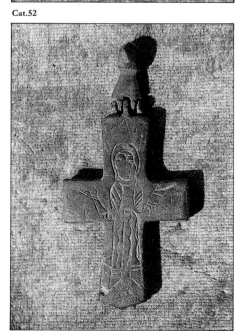

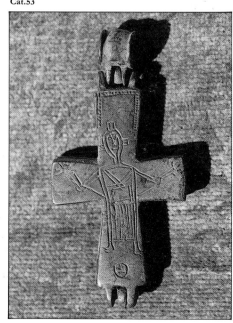

Cat.55

Cat.56

of God, before, during and after the birth of Christ. Four centuries later, Leo VI (886–912) issued coins bearing this image and it was circulated in a standardised form throughout the empire. The image later developed into the *Znamenie* or 'Virgin of the Sign' in Russian icon painting.

48. Silver Reliquary Cross

Asia Minor/Palestine
6th–9th century
Height: 9.4 cm
Illustrated on page 91

The decoration of the cross is engraved. On the front of the cross, the Mother of God is depicted in the *orans* position. The inscription RCO XPC NIK may be a version of $X\rho\iota\sigma\tau\sigma\varsigma\ \nu\iota\chi\alpha$, meaning 'Christ conquers'. The back is decorated with a roundel at the centre (with a later blue inlay) and busts of four apostles identified by inscriptions. These include ΠΕΤΡΟC (St Peter) at the top and HOANHC (St John).

49. Reliquary Cross

Asia Minor/Palestine
6th–9th century
Bronze
Height: 8.3 cm

The cross is decorated in relief. On the front there is a Crucifixion with Christ wearing a *colobium* (the long, sleeveless or short-sleeved garment often seen in early Christian representations of the crucified Christ). The Mother of God and St John can be seen to his left and right. They can be identified from the inscription (John 19, 26–7) which reads: IΔΕ OY(C)/COY IΔΕ YO(C)/COY ('Behold your mother, Behold your son'). On the back of the cross, the Mother of God stands in the *orans* position. At the extremities there are busts of the four evangelists.

50. Reliquary Cross

Asia/Palestine
6th–9th century
Bronze
Height: 9.3 cm
Illustrated on page 91

The decoration on this cross is engraved. On the front, the Mother of God stands in

the *orans* position. She is identified by an inscription. On the back, there is a cruciform pattern with five settings for glass inlay. There are protruding nodes at each of the eight corners of the cross.

51. Reliquary Cross

Asia Minor/Palestine
6th–9th century
Bronze
Height: 9.8 cm
Illustrated on page 91

The decoration is engraved. On the front of the cross, the Mother of God stands in the *orans* position. She is identified by an inscription. On the back, there is a cruciform pattern with five settings for glass inlay.

52. Reliquary Cross

Asia Minor/Palestine
6th–9th century
Bronze
Height: 9.8 cm
Illustrated on page 91

The decoration is engraved. On the front of the cross there is a Crucifixion. Christ is bearded and wears a *colobium* (cf. catalogue no. 49). The inscription beneath the arms of the cross reads: IC XC NHKA , meaning 'Jesus Christ Conquers'. On the back, the Mother of God, identified by an inscription, stands in the *orans* position.

53. Reliquary Cross

Asia Minor/Palestine
6th–9th century
Bronze
Height: 9.3 cm
Illustrated on page 91

The decoration is engraved. On the front of the cross there is a Crucifixion. Christ is bearded and wears a *colobium* (cf. catalogue no. 49). On the back, the Mother of God, identified by an inscription, stands in the *orans* position.

54. Reliquary Cross
Asia Minor/Palestine
6th–9th century
Bronze
Height: 9.8 cm
Illustrated on page 91 and in colour on page 23

The decoration is engraved. On the front of the cross, St John is standing in the *orans* position. He is identified by an inscription: **HOANNHC** . On the back, there is a cruciform pattern with five settings for glass inlay.

55. Reliquary Cross
Asia Minor/Palestine
6th–9th century
Bronze
Height: 11.9 cm
Illustrated on page 91

The decoration is engraved. On the front of the cross, the Mother of God, identified by an inscription, stands with her hands raised at her sides in the *orans* position. On the back, there is a geometric pattern with five settings for glass inlay. The gold leaf is a later addition.

56. Reliquary Cross
6th–9th century
Bronze
Height: 8.2 cm
Illustrated on page 91

The decoration is engraved. On the front of the cross, there is a representation of Christ crucified. The engraver appears to have confused the regular *orans* saint with the Crucifixion. The cruciform nimbus and the skull at the base of the cross (representing the head of Adam) indicate that the figure is Christ. The image is, however, unlike other Crucifixions (cf. nos. 49, 52 and 53). The back is decorated with geometric patterns.

57. Reliquary Cross
Asia Minor/Palestine
6th–9th century
Bronze
Height: 8.1 cm

The decoration is engraved. On the front of the cross, St George stands with arms raised in the *orans* position. He is identified by an inscription: ΓΕΟΡΓΗΟϹ .On the back, the Virgin is represented as *Panagia*, also in the *orans* position. *Panagia*, meaning 'All Holy', was the name given to the Virgin after her motherhood of Christ was confirmed at the Council of Ephesus in AD 431. The word ΠΑΝΑΓΙΑ (Panagia) is inscribed above her. The hinge and two of the arms are broken.

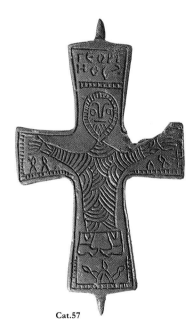
Cat.57

58. Reliquary Cross
Asia Minor/Palestine
6th–9th century
Bronze
Height: 8.4 cm

Only the top half of the cross has survived. It is engraved with a figure in the *orans* position.

PENDANT CROSSES

In the early Christian period, it was common for Christians to wear an *enkolpion* – a cross, medallion, relic-holder or other hanging object – on a cord round the neck as a source of divine favour or blessing. Among the most popular of these objects were pendant crosses. These were being made from the sixth century onwards.

Pendant crosses are among the most common of all the objects that survive from the early Christian world. They were made from a variety of different materials, including bone, bronze, iron, silver, gold and glass and they appear in various shapes and sizes. They were used at every level of society. Particularly in the eighth and ninth centuries during the period of 'Iconoclasm' (when figurative representation was forbidden by the Orthodox Church), the undecorated form of the cross was revered as the sign of Christian revelation.

Most pendant crosses were cast in bronze. Some of the larger examples are decorated with saints or simple figurative scenes, but, for the most part, these crosses were plain. They were occasionally decorated with small rings drilled on to their surfaces.

Note

1. For a similar collection of pendant crosses, see M. C. Ross (ed.), *Early Christian and Byzantine Art*, Walters Art Gallery, Baltimore, 1947, no. 449.

59. Pendant Cross
Asia Minor/Palestine
7th century
Bronze
Height: 6.7 cm
Illustrated on page 97

The arms of the cross are lobed. The Crucifixion is represented in relief on the front.

60. Pendant Cross
Asia Minor/Palestine
7th century
Bronze
Height: 8.6 cm
Illustrated on page 97

The arms of the cross are round and undecorated. It has a large ring at the top.

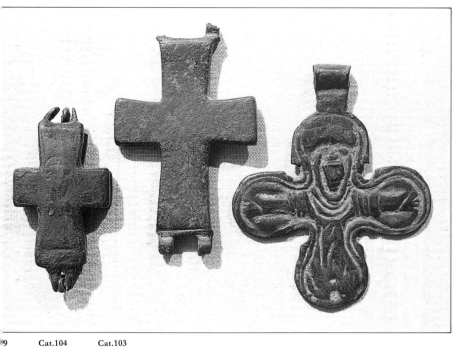

Cat.104 Cat.103

Cat.60

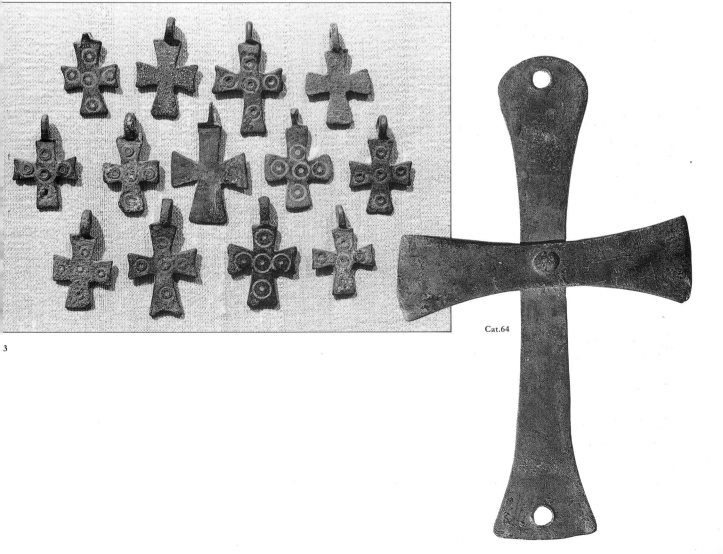

Cat.64

61. Pendant Cross
Asia Minor/Palestine
8th century
Bronze
Height: 2.7 cm
Illustrated on page 104

62. Pendant Cross
Asia Minor/Palestine
8th century
Bone
Height: 2.2 cm
Illustrated on page 104

Geometric patterns are engraved on the front and back of the cross. A minute hole for thread has been drilled from the side through the top of the cross.

63. Thirteen Pendant Crosses
Asia Minor/Palestine
7th–8th century
Bronze
Height: 2.5–3.5 cm
Illustrated on page 97

Each of the crosses has a small suspension loop at the top.

64. Pendant Cross
Asia Minor/Palestine
6th century
Bronze
Size: 14.8 × 8.8 cm
Illustrated on page 97

The arms of the cross are riveted together. The two holes in the vertical shaft indicate that it originally formed part of a polycandelon or hanging lamp (cf. catalogue nos. 44 and 45).[1]

Note

1. See also *Byzantium: Light in the Age of Darkness*, New York, 1989, no. 5.

PROCESSIONAL CROSSES

Throughout history and in most societies special occasions have been celebrated with processions. The early Byzantine period was no exception. The Holy feast days of the church were regularly observed with processions. Gratitude to God for victory in battle or a fruitful harvest was also demonstrated with an occasion of public celebration.

Public processions were organised by the church. The procession was led by the church elders and a cross or an icon or a holy relic was held up at the helm. It was customary to take a processional object to battle where it was believed to serve as a spiritual shield against the enemy. (The use of icons in battle is depicted in the well-known fifteenth-century icon of 'The Novgorodians against the Suzdalians' in the Tretyakov Gallery.[1])

Processions also form an integral part of the liturgical services of the Orthodox Church. In the part of the liturgy known as the 'Little Entrance', a book of the gospels, traditionally regarded with the same reverence as an icon, is carried in procession round the church; and in the 'Great Entrance', the holy bread and wine are brought in procession from behind the iconostasis up to the altar.[2]

Notes

1. Cf. *Early Russian Icon Painting*, M. Alpatov, Moscow, 1974, pl. 114.

2. See also *Byzantium: Light in the Age of Darkness*, New York, 1989, nos. 6, 10, 11.

65. Processional Cross with Foliate Scrollwork
Asia Minor
11th–13th century
Bronze
45 × 28.5 cm
Illustrated in colour on page 21

It was not uncommon for Byzantine craftsmen to use foliate scrollwork as a method of decoration in their metalwork, but its use in the present context of a processional cross is unusual. Judging by the number of Byzantine processional crosses that have come down to us with broken arms, it seems likely that this detail was originally conceived as a form of extra support to the horizontal arms of the cross. Precedents for this arrangement can however be found in crosses depicted in other materials. A silver-gilt repoussé reliquary in the Hermitage Museum is one example.[1] The horizontal arms of both crosses are supported by leafy scrolls and the ends of each arm terminate in unusually large lobes.

The cross was originally mounted on a staff.

Note

1. See A. Bank, *Byzantine Art in the Collections of Soviet Museums*, Leningrad, 1985, no. 201. Cf. also no. 183.

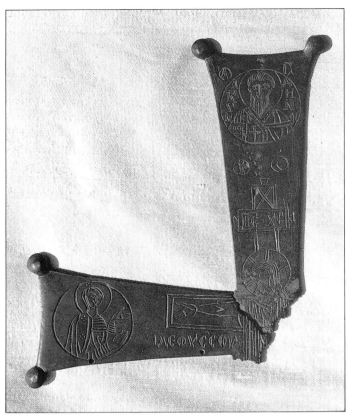

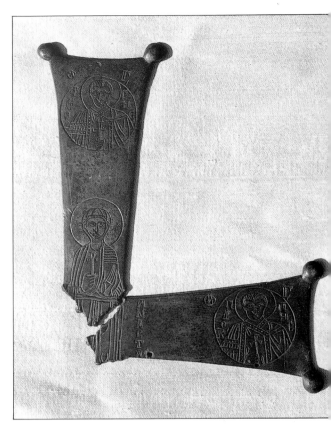

Cat.66

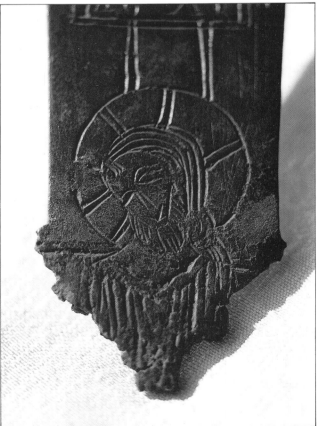

Cat.66 detail

66. Two Fragments of a Processional Cross

Asia Minor/Palestine
10th century
Bronze
Lengths: 10.5 cm and 15.5 cm

On the front of the cross is a Crucifixion. Only the head and right arm of Christ can still be seen. Christ is wearing a *colobium* (cf. no. 49). Above Christ, a plaque is fixed to the cross with the inscription ΙC ΧC , a formal abbreviation of his sacred name. Two discs indicate the sun and the moon. Above these discs, at the top of the vertical shaft, the figure of a bearded saint appears within a roundel. He is identified by an inscription, ΑΓ(ΙΟC) ΑΚΥΝΔΗΝΟ(C) , as being St Akindynos.

St Akindynos is a little-known saint who lived in the fourth century. His canonisation in the Eastern Church is due to the courage he showed in his attempt to convert King Shapur II of Persia (311–80) to Christianity. His mission was a failure and he and his companions suffered mercilessly at the hands of the Persians. A chapel was built in his memory on the island of Lesbos. He is remembered on 2 November.

At the end of the left arm of the cross, the Mother of God appears with hands upraised in the traditional posture. The inscription beneath the arm of the cross is incomplete. The surviving part reads ΙΔΕ ΟΥ(Ο)C COΥ. This mean 'Woman, behold thy son . . .' and forms the first half of the traditional passage from the gospel of St John 19, 26–7: 'Woman, behold thy son. Behold thy mother'. (See also no. 49).

On the back of the cross, a female figure identified as ΑΝΑCΤΑC (Anastas), stands at the centre. St Anastasia was martyred in the fourth century. The word *Anastasis* is the Greek word for Resurrection. St Anastasia may therefore have been chosen to decorate this cross in order to complement the Crucifixion represented on the front. In one hand she holds a cross; her other hand is raised. In the roundel above her, there is a bust of St George and on the right arm, a bust of the warrior St Procopius. Both saints are identified by inscription: ΑΓ(ΙΟC) ΓΕΟΡΓΗ(Ο)C ΑΓ(ΙΟC) ΠΡΟΚ(Ο)ΠΝ(Ο)C . Towards the end of the third century, St Procopius was given a military title by Diocletian, the Roman emperor. Following a vision that he had, at war, of a great cross shining in the sky, he was converted to Christianity and turned his troops to the defence of Jerusalem. Although both St George and St Procopius were warriors, they were occasionally depicted each wearing a *dalmatic* – a long tunic with wide sleeves, typically associated with martyrs.

The cross can be dated to the tenth century. The flared arms ending in lobed tips are a characteristic feature of crosses from this time.[1]

Note

1. See Nesbitt, 'An Inscribed Byzantine Bronze Cross', *Journal of the Walters Art Gallery*, no. 44, 1986, p. 8.

67. Processional Cross with St Nikita

Asia Minor/Palestine
11th century
Bronze
19.6 × 13.6 cm
Illustrated in colour on page 23

The cross is decorated with an engraving of St Nikita. St Nikita is often represented in later Russian metal icons brandishing a club in one hand and a devil in the other, but he is rare in Byzantine art. He is identified by an inscription: NIKITA IC.

The saint is standing in the *orans* posture. This posture is well adapted to the shape of the cross and was the most common representation of prayer until the tenth century. One straight line and a wavy line decorate the extremities of each of the arms of the cross.[1]

The cross was originally mounted on a staff. The soldering point can be seen at the base of the cross. The back of the cross is plain. One of the lobes is missing.

Note

1. For a comparison of the style of engraving and the decorative lines see *Byzantium: Light in the Age of Darkness*, no. 10.

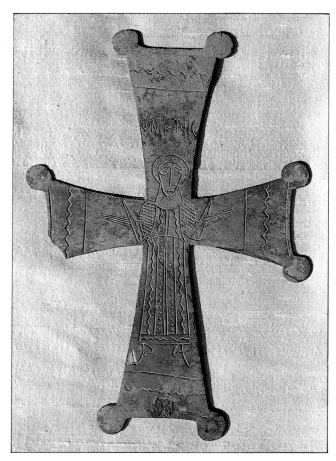

Cat.67

68. Processional Cross
Asia Minor/Palestine
6th–8th century
Bronze
Height: 3.2 cm
Illustrated on page 104

69. Processional Cross
Asia Minor/Palestine
6th–9th century
Bronze
Size: 13.5 × 9.0 cm

The cross is decorated with parallel lines and rings. For processional purposes it was soldered to a pin and mounted on a staff. A small hole and a distinctive section of wear at the bottom of the cross are evidence of this.

70. Processional Cross
Asia Minor/Palestine
6th–9th century
Bronze
Size: 15 × 9.9 cm

The cross is comparable to no. 69. It was originally mounted on a staff. Evidence of the fastening-pin can be seen at the bottom. It is undecorated.

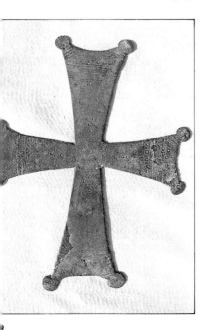

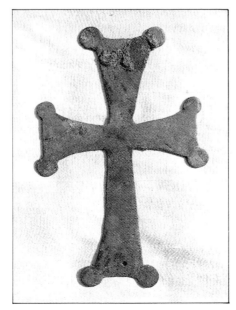

Cat.70

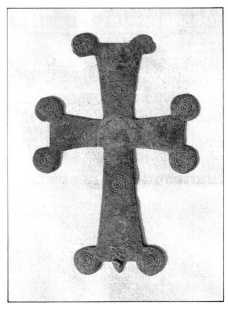

Cat.71

71. Processional Cross

Asia Minor/Palestine
9th–10th century
Bronze
Height: 11.9 cm
Illustrated on page 103

The cross is decorated with simple concentric circles on the arms and in each of the lobes. Traces of a decorative applied roundel can be seen at the centre of the cross. The cross was originally mounted on a processional staff. Its mounting pin still survives at the base.

72. Two Casket Handles

Asia Minor
9th–10th century
Bronze
Height: 12.6 cm

The cross handles have protrusions at the corners, as was the custom for crosses of this period.

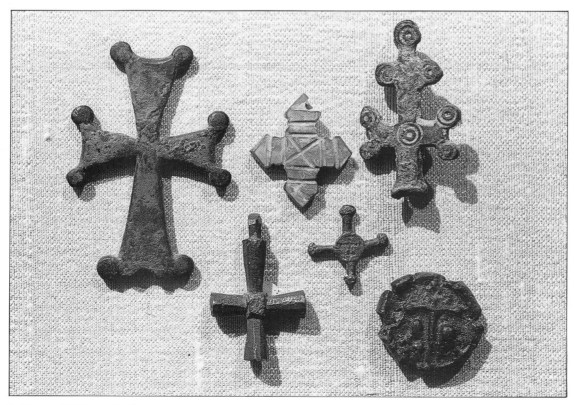

Cat.74 Cat.62 Cat.68
 Cat.73
 Cat.61 Cat.91

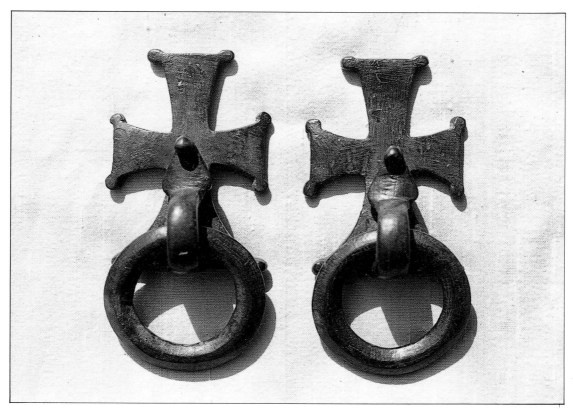

Cat.72

73. Bronze Cross
Asia Minor
8th century
Height: 1.5 cm

A small cross is engraved at the centre of both sides of the cross.

74. Bronze Cross
Asia Minor/Palestine
6th–8th century
Bronze
Height: 4.5 cm

75. Bread Stamp

Byzantine
5th–6th century
Bronze
Diameter: 8.4 cm

Stamps and seals were used throughout antiquity for both religious and secular purposes. The present stamp is clearly of Christian origin. At the centre of the stamp there is a *Chi-Rho* monogram, within a circle of rings. The inscription round the outside reads: ΥΓΙΑ ΓΕΝΝΑΔΙΩ ('Health to Gennadios'). The presence of a personal invocation in this context reflects the pagan precedent for the tradition of stamping bread. The stamp has a looped handle on the back.[1]

Notes

1.For a set of comparable bread stamps see Weitzmann (ed.), *The Age of Spirituality*, New York, 1977, no. 565.

Cat.75

76. Votive Hand with Cross

Palestine
6th–7th century
Bronze
Height 13.8 cm
Illustrated in colour on page 22

A number of votive hands from the early Christian period have survived, but their exact function remains unclear. It has been suggested that they were used as part of a healing process, possibly in connection with the 'laying on of hands', an ancient and traditional form of healing that is endorsed in antiquity, gnosticism and the gospels. What is clear is that a series of cast bronze hands originating from the region of Thrace and datable to antiquity can be associated with the cult of Sabazios, the Phrygian nature god.[1]

It seems likely that the universal gesture of the raised hand was passed on to Christianity through the complex mixture of cult religions that was characteristic of the late Roman Empire. The gesture was used as a sign of benediction in Christian ritual and iconography, but its somewhat pagan flavour indicates that it may also have been used as an expression of the supremacy of the theocratic state.[2]

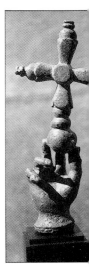

Cat.76

Notes

1. Cf. *The Age of Spirituality*, New York, 1977, nos. 163 and 557.

2. Cf. 'Byzantine Bronze Hands Holding Crosses', *Archaeology*, 17, pp. 101–3.

BUCKLES

Throughout antiquity, buckles were often highly decorated with both figurative and geometric designs. The large number of buckle plates that are decorated with Christian iconography reflects how, during the early Christian and Byzantine period, the reality of Christian revelation influenced even the most commonplace aspects of everyday life. A collection of similar buckles can be seen at the British Museum.

77. Buckle Plate

Asia Minor
7th–8th century
Bronze
Length: 5 cm
Illustrated on page 108

The buckle plate is decorated with an engraving of Christ, his right hand raised in blessing. He is enthroned between two angels.

78. Buckle Plate

Asia Minor
7th–8th century
Bronze
Length: 4.7 cm

The buckle plate is cast in the form of a cross. It is decorated with concentric circles incised into the arms of the cross.

79. Buckle Plate

Asia Minor
7th–8th century
Bronze
Length: 5.1 cm

The buckle plate is cast in the form of a cross. It is decorated with concentric circles incised into the arms of the cross. The fastening pin is missing.

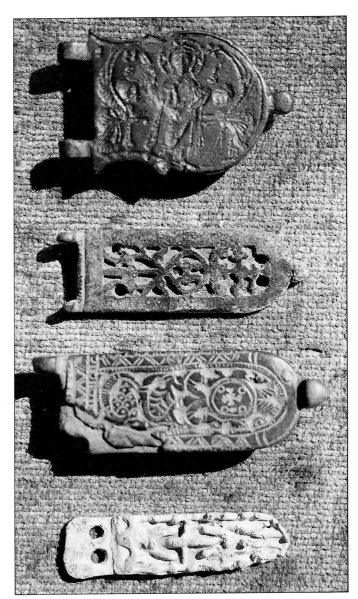

Cat.77

Cat.80

Cat.81

Cat.82

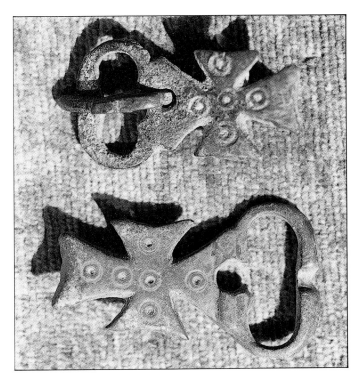

Cat.78

Cat.79

80. Buckle Plate

Asia Minor
7th–8th century
Bronze
Length: 5.5 cm
Illustrated on page 108

81. Buckle Plate

Asia Minor
7th–8th century
Bronze
Length: 6.3 cm
Illustrated on page 108

The buckle plate is engraved with a decorative pattern that includes a small cross at the centre.[1]

Note

1. A similar buckle plate from the Dumbarton Oaks Collection is illustrated in A. Yeroulanou, 'The Byzantine Openwork Gold Plaque in the Walters Art Gallery', *Journal of the Walters Art Gallery*, 1988, p. 4, fig. 3.

82. Buckle Plate

Asia Minor
7th–8th century
Lead
Length: 4.9 cm
Illustrated on page 108

The decoration of the buckle plate is engraved. It includes a cross at the centre.

83. Buckle Plate

Asia Minor
7th–8th century
Bronze
Length: 5.1 cm

The decoration of the buckle plate is based on a tear-shaped pattern.[1]

Note

1. A comparable buckle plate from the Walters Art Gallery Collection is illustrated in Yeroulanou, op. cit., p. 4, fig. 4.

84. Buckle Plate

Asia Minor
7th–8th century
Bronze
Length: 5.3 cm

85. Buckle Plate

Asia Minor
7th–8th century
Bronze
Length: 3.6 cm

PILGRIM TOKENS, AMULETS, COINS AND OTHER ITEMS

PILGRIM TOKENS

It was common for pilgrims to the holy sites to acquire souvenirs of their visit. These souvenirs included small portable reliquaries, designed to contain relics (see nos. 48–58) and ampoules or phials, filled with pieces of earth or small quantities of water that served as relics of a holy place.

Among the most popular forms of souvenir were simple terracotta 'eulogia' (blessing) or pilgrim tokens. *Eulogia* tokens were made from the earth of a holy site. A small amount of earth was compacted into a round shape and was then impressed with a seal that identified the source of its sanctity.

Unlike other forms of Christian memento, *eulogia* tokens also adopted some of the qualities usually associated with antique or gnostic gems. Such gems were considered to be magical objects that embodied the psychic force of the spiritual world and released it to those who invoked them correctly. The magical properties of amulets and gems were highly regarded in antiquity and the same attitude survived well into the early Christian period. In later years it became fully integrated into Christianity in a more developed form – through the sacramental function of the icon. In the case of *eulogia* tokens, both the actual substance of the token and the commemorative image itself were considered to be charged with blessings.[1]

Note

1. For a full consideration of the magical or iconic use of *eulogia* tokens, see Vikan (ed.) *Icon: Four Essays*, Walters Art Gallery, 1988, pp. 6–20.

86. Pilgrim Token with St Simeon Stylites

Asia Minor
5th–7th century
Compacted clay
Diameter: 2.6 cm

St Simeon Stylites was an ascetic monk renowned for having spent most of his life at the top of a pillar. By the time of his death in AD 459, the pillar had reached the height of sixty feet. The space at the top was large enough for him to sit and stand but not to lie down. Food was brought to him up a ladder, as depicted here to the right of the saint. St Simeon attracted much attention and many monks were moved to follow his example of extreme asceticism. Such hermits were named 'stylites', from the Greek

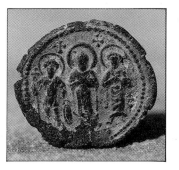
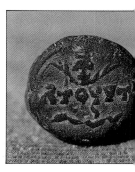

Cat.86 Cat.87 Cat.88 Cat.89

word meaning a pillar. St Simeon spent his time in ceaseless prayer and teaching and exercised a considerable influence on the world around him. In the Orthodox Church he is remembered on 1 September.

Among the most common of *eulogia* tokens are those that represent St Simeon. In the *Life* of the saint we are told that St Simeon himself admonished a pilgrim to take a token, 'made of my dust, depart and when you look at the imprint of our image, it is us that you will see'.[1]

The stylite can be seen at the centre of the token. Two angels circle about his head. The scene depicted to the left is probably a baptism.[2] A standing figure appears to the right.[3]

Notes

1. Vikan (ed.), op. cit., p. 14.

2. For a discussion of this question, see the *Catalogue of the Byzantine and Early Mediaeval Antiquities in the Dumbarton Oaks Collection*, vol. 1, Washington, 1962, no. 92, p. 76 and pl. L.

3. For an illustration of a St Simeon token in the Menil Collection, Houston, cf. Vikan, op. cit. p. 13.

87. Pilgrim Token with St Simeon Stylites

Asia Minor
5th–7th century
Compacted clay
Diameter: 2.4 cm

Similar to no. 86. To the left of the pillar there is an amphora and to the right, a ladder. The angels above hold palm fronds.

88. Pilgrim Token with Three Saints

Asia Minor
5th–7th century
Compacted clay
Diameter: 2.7 cm

The token depicts three saints with nimbi within a dotted ring. The figure to the left, standing in the traditional posture of a warrior may be St George or St Demetrius. The other two saints are bishops or deacons. The one to the right is holding a processional cross. Small crosses occupy the spaces between their heads.

89. Pilgrim Token with Inscription

Asia Minor
5th–7th century
Compacted clay
Diameter: 2.1 cm

The inscription on the token has not been deciphered.

90. Pilgrim Token with Cross

Asia Minor
5th–7th century
Terracotta
Diameter: 1.5 cm
Illustrated on page 114

In the spaces between the four arms of the cross there are four letters. These cannot be deciphered but may represent the name of a saint or holy place.

91. Pilgrim Token with Cross

Asia Minor
5th–7th century
Terracotta
Diameter: 1.9 cm
Illustrated on page 104

Two figures can be seen at the base of the cross.

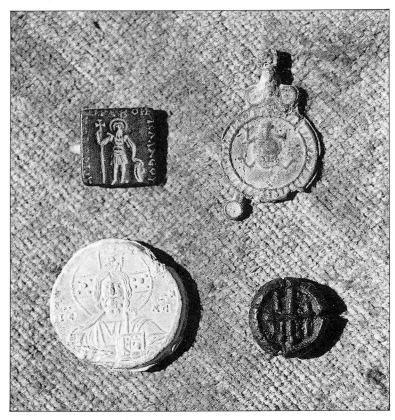

Cat.97 Cat.92
Cat.93 Cat.90

92. Lead Amulet

Asia Minor
2nd or 3rd century
Diameter: 1.9 cm
Illustrated on page 114

The amulet was designed to hang from a suspension loop at the top; it has one protuberance at the bottom (left) and one missing. On one side of the amulet there is a Greek cross; on the other side, there is a beetle-like creature. This may have been derived from the scarab, an ancient Egyptian symbol which was believed to reproduce itself (without recourse to a partner) from balls of dung and was therefore believed to relate to the sun as stimulus for the self-regenerative capacity of nature. Carvings of scarabs were worn by priests and were invoked as sources of health and well-being.

Magical amulets and gems were popular throughout antiquity. They were used as mediums through which a variety of natural psychic forces could be invoked. An appreciation of the magical qualities of gems was continued well into the Christian era but was condemned by conventional Christianity. See also the introduction to Pilgrim Tokens on page 111.

3

93. Seal
Asia Minor
976–1025 (?)
Lead
Diameter: 2.8 cm
Illustrated in colour on page 23

On one side of the seal we see a bust of Christ Pantocrator. His right hand is raised in blessing. On the other side, there is a bust of a crowned emperor, possibly Basil II, the Bulgar-slayer. In his right hand he holds a sceptre. The inscription reads: BA . . . AYTOC(P)ATOP.

 The association of the emperor with Christ is based on the traditional Byzantine notion that the emperor is Christ's representative on earth and that, accordingly, due reverence should be shown to him. Up until the conversion of Constantine at the beginning of the fourth century, Christianity was particularly distinguished from other cult religions in that it refused to pay homage to a pagan emperor.

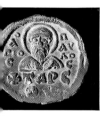

4

94. Seal with St Paul of Tarsus
Asia Minor
6th–7th century
Lead
Diameter: 2.5 cm
Illustrated in colour on page 23

On one side of the seal we see the bearded figure of St Paul of Tarsus. He is identified by an inscription: AΓIOC ΠAYΛOC TAPC. On the other side, there is a cross monogram.[1]

Note

1. A very similar seal from the Dumbarton Oaks Collection is illustrated in Vikan, 'Early Christian and Byzantine Rings in the Zucker Family Collection', *Journal of the Walters Art Gallery*, 45, 1987, p. 39, fig. 14.

95. Ring with Mounted Warrior
Asia Minor
6th–7th century
Bronze
Diameter: 2.4 cm

On the bezel, a nimbed saint is represented in intaglio, mounted on a horse. He carries

a processional cross. Rings were common to antiquity as signets and were easily adapted to the requirements of Christian iconography.

Some significant developments have been observed in the history of rings in the early Christian period. In contrast with the popular figurative gems that were characteristically inserted into Roman rings, Byzantine rings were more commonly made from a single metal and they were decorated as much with inscriptions as with images. Byzantine rings also developed an iconic significance that is not found in their Roman precedents.[1] The present ring is not deeply enough engraved to have been a signet ring and therefore probably served an iconic purpose.

Note

1. For a full discussion of the context and development of rings in the early Christian world, see Vikan, 'Early Christian and Byzantine Rings in the Zucker Family Collection', op. cit., p. 32.

96. Ring with Bust of Saint

Byzantine
6th–10th century
Silver
Diameter: 2.2 cm
Illustrated in colour on page 23

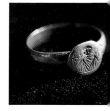

Cat. 96

97. St Theodore

Asia Minor
6th–7th century
Bronze intaglio
1.6 × 1.5 cm
Illustrated on page 114

The warrior is depicted in intaglio on the bronze. He is identified as St Theodore by an inscription, which reads: ΑΓΙΟ(C) ΘΕΟΔ(W)ΡΕ ΒΟΗ(Θ)Ι (ΤΗ) Δ (ΟΥ)ΛΑ COY , ('Saint Theodore, help your servant'). In his right hand, St Theodore holds a staff topped with a cross; in his left hand, he holds a shield. He stands in a typical Byzantine warrior posture (cf. the silver-gilt icon of St George, catalogue no. 7). Evidence of a strap at the back of the piece suggests that it was originally mounted, possibly as the bezel of a ring.

Square bezels are not uncommon in Byzantine rings.[1] Warrior saints and full-length figures were popular subject matter on rings.[2]

Notes

1. See Vikan, 'Early Christian and Byzantine Rings', op. cit., p.34, figs. 7 and 8.

2. Ibid., p. 41, figs. 10 and 21.

3. For a full description of how the blessing power of a saint was believed to be transmitted through the agency of a small gem, a pilgrim token or a ring, see Vikan, *Icon: Four Essays*, Walters Art Gallery, 1988, pp. 12–18.

98. Bronze Weight

Byzantine
6th–10th century
Diameter: 3.4 cm

The weight is inscribed on the top with letters **N** and **IB**, composed of incised lines and strings of drilled holes. The weight was turned on a lathe. Above the prominent hub, there is a cross. The back is plain.

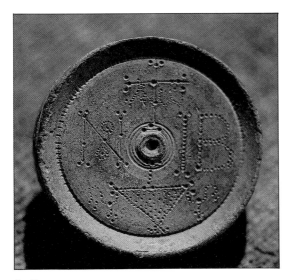

Cat.98

Cat.99

99. Ivory Plaque with Wood-cutter

Byzantine
12th century
5.5 × 4.4 cm

The ivory depicts a wood-cutter with his axe raised to fell a tree (visible to the right). Traces of red pigment show that the plaque was originally painted. Three pin-holes indicate how it was fastened in its original setting which was probably a casket decorated with pastoral scenes.[1]

Note

1. Similar plaques form part of the casket shown in Randall, *Masterpieces of Ivory from the Walters Art Gallery*, 1985, nos. 201, 202.

100. Byzantine Coin (*histamenon nomisma*)

Constantinople
1042–55
Gold
Diameter: 2.8 cm

The coin was minted in Constantinople. On one side, there is a representation of Christ, enthroned. An inscription reads: **IhC XIS REX REJNANTIUM** (Jesus Christ, King of Kings). On the other side, we see the Emperor Constantine IX, also identified by an inscription: **+ CONCȚANTh BASIΛEUS RM** (Constantine Emperor of the Romans).

The apotheosis of the emperor was taken for granted in the Roman world. It is not surprising, therefore, that, from the time of the conversion of the Roman state to Christianity at the beginning of the fourth century, the identification of the ruling emperor with Christ became a characteristic feature of the Byzantine world. The emperor considered himself to be the single representative of Christ on earth and he demonstrated his relatedness to Christ by making associations of the kind we see in the present coin. It was in order to consolidate this notion that the iconography of Christ as Emperor developed to the extent that it did in the Byzantine era.

On the front of the coin, Christ is represented as Pantocrator – Ruler of the World. He is seated on an imperial throne 'in state'. His feet rest on a footstool. On the back, there is a portrait bust of Emperor Constantine II. The emperor is shown in military attire, holding a sceptre in his right hand and an orb, surmounted by a patriarchal cross, in his left. These attributes indicate the emperor's authority and sovereignty over the world.[1]

Note

1. For further information on Byzantine coins, see P. Grierson, *Byzantine Coins*, London, 1982.

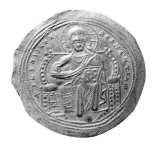

1

101. Gold Intaglio with Monogram

Byzantine
6th–7th century
Diameter: 1.3 cm
Illustrated in colour on page 19

Although the exact function of the intaglio is unknown, it seems probable that it formed part of a personal adornment. It has finely corrugated sides and there are traces of a fastening device on the inside.

The intaglio is inlaid with a box monogram within a ring of curls of the kind used in the classical world to represent waves. A box monogram is a type of signet in which all the letters of a given name or word are superimposed on each other. The fashion for box monograms flourished from the fourth until the sixth or early seventh century. They were particularly common on rings.[1]

The letters on our intaglio appear to comprise the name ZENO.

Note

1. See Weitzmann (ed.), *The Age of Spirituality*, New York, 1977, p. 317, no. 293. Also Vikan, 'Early Christian and Byzantine Rings', op. cit., p. 39; *Catalogue of the Byzantine and Early Mediaeval Antiquities in the Dumbarton Oaks Collection*, vol. I, Washington, 1962, no. 118, pl. LVII.

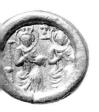

02

102. Byzantine Coin

8th–11th century
Gold
Diameter: 1.5 cm

On the front of the coin, two enthroned figures are represented. The figure on the left is an emperor; he is nimbed and crowned and holds an orb in his left hand. His right hand is raised. The figure on the right is partly truncated by the raised border. What remains of this figure is almost identical to the first one.

The incompleteness of the image suggests that it has been cut down and mounted in a setting that was not originally designed for it. The edge of the throne will originally have been reflected symmetrically on the right hand side and the cross between the two figures will have been central. The feet of both figures should be visible. There are no inscriptions.

The exact function of this piece is not clear. It has been suggested that the central part was originally a coin. The clasps at the back suggest that it was adapted (at an early date) to function as a personal adornment.

103. Reliquary Cross

Asia Minor/Palestine
6th–9th century
Bronze
Height: 4.8 cm
Illustrated on page 97

The cross was originally decorated with an engraving of Christ crucified, only traces of which are now discernible.

104. Reliquary Cross

Asia Minor/Palestine
6th–9th century
Bronze
Height: 6.2 cm
Illustrated on page 104

Only one half of the cross has survived.

105. Reliquary Cross

Asia Minor
6th–9th century
Bronze
Height: 8.5 cm

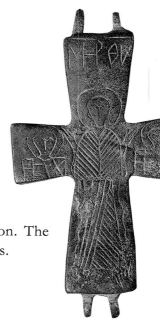

Cat.105

The Mother of God, identified by an inscription, is shown in the *orans* position. The busts of two unidentified saints are represented in the lateral arms of the cross.

106. Amulet with Warrior

Asia Minor
6th century
Haematite
3.1 × 1.9 cm

A warrior in classical Roman armour is depicted killing a dragon with a spear. An inscription identifies the figure as St George but the naturalistic style of the engraving together with the classical style of armour suggest that the inscription, which is more crudely executed than the rest of the piece, was added at a later date. The motif of a warrior overcoming a serpent or dragon was a conventional means for representing the victory of the forces of good over the forces of evil.